# VAN GOGH

# Van Gogh

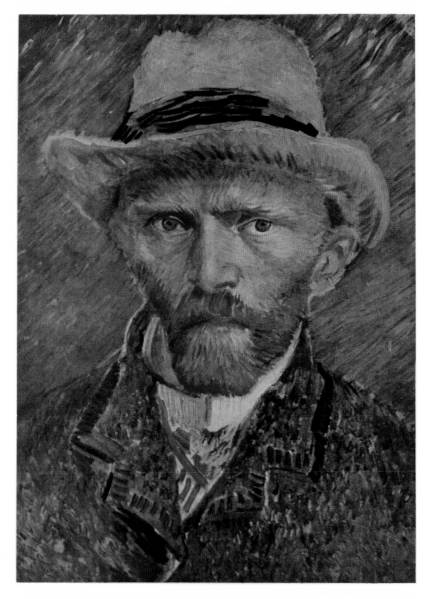

BY RENÉ HUYGHE

CROWN PUBLISHERS INC. · NEW YORK

*Title Page:* SELF PORTRAIT. Canvas, Paris Period. 19"×15"
Rijksmuseum, Amsterdam

*Translated by:*

HELEN C. SLONIM

PRINTED IN ITALY.

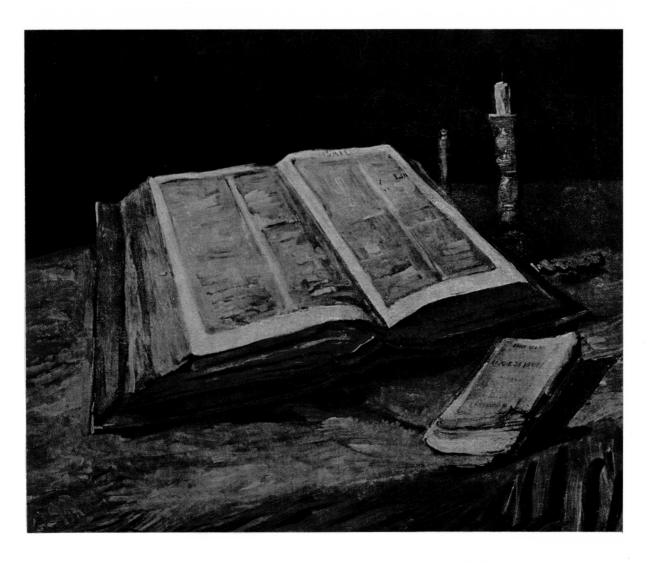

STILL LIFE WITH OPEN BIBLE. Canvas. 26″ × 32″ Nuenen Period, 1885.
V. W. Van Gogh's Collection, Amsterdam.

We are awed before we even start writing about Van Gogh: it is not of a painter, but of a soul, that we are about to speak. This is the story of a soul fighting against the supreme problems of destiny. Van Gogh lived these problems in the core of the tragedy which makes the modern world — our tragedy — with its outbursts, its unlimited yearning, its failures, its desperation. However present, however much a symbol of our times, his work cannot only be considered, in its paroxysm, as an image of contemporary soul; it also unveils, in its deepest expression, the soul of

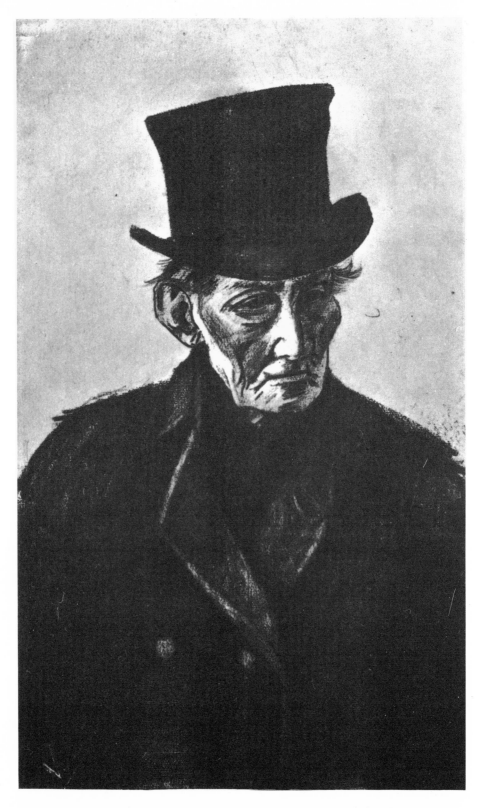

*Old Man with Top Hat. Blackpencil, ink and washtint. 24'' × 14½''*
*The Hague Period, 1882. V. W. Van Gogh's Collection, Amsterdam.*

eternal man. Few writers, few artists, have felt and expressed, as Van Gogh did, the pathetic situation of human condition.

This tragedy, into which he threw himself until he could but die, is the tragedy of going beyond, the tragedy of the absolute which burns out the purest and most exacting souls. They all suffer from man's duality; man hanging, torn, between two poles: one still in contact with the beast, the other already reaching up to God. This is man's unsolvable paradox. Being of the flesh, he is deeply etched in the physical world and its sorrows; he bears the brand of all that is matter; he is an accident which happened in space and time; accidentally appearing in a universe which he does not understand but which he suffers, his fate is to disappear with the second which carries him; decay is his only short reprieve from nothingness. But man is also a being of the soul and, as such, has a yearning for absolute; if he can neither achieve it nor live it, he can at least conceive it and be obsessed by it. He perceives a conscience of which he is only the infinitely small and caricatural image, which would break loose from the particular, from the transitory, from the uncertain: he calls it God. There he lies, miserable and awed, hanging between abjection and glory. Different from all other living creatures of this world, he is conscious of this

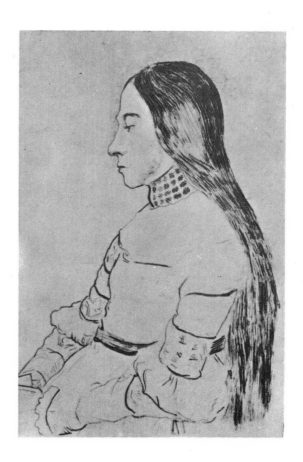

*Copy from a Drawing of Holbein. Presently in the Basel Museum, Representing Anna Meyer. Pen. 22" × 17" Brussels Period, 1880. Mrs. H. Kröller Müller's Collection, The Hague.*

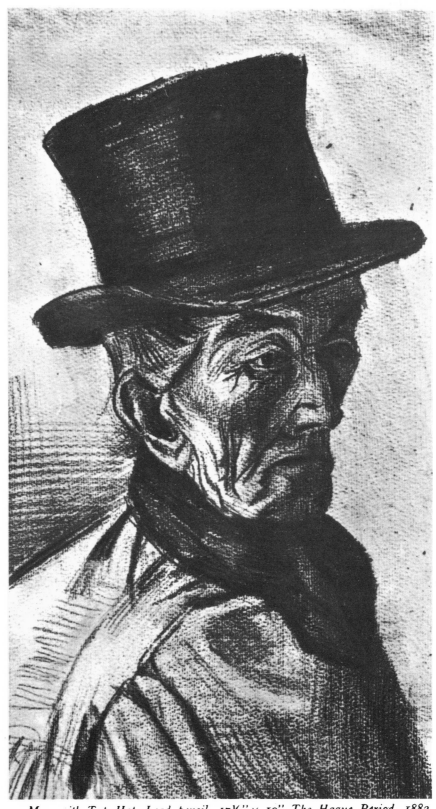

*Man with Top Hat. Lead pencil. 17½″ × 10″ The Hague Period, 1882.*
*D. Hannema's Collection, Rotterdam.*

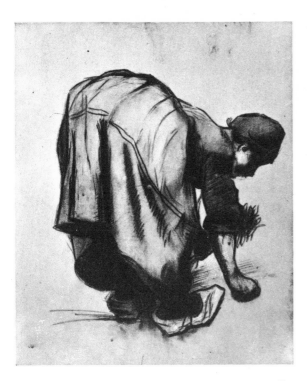

*Peasant Woman Bending Over. Black pencil. 21" × 17" Nuenen Period, 1885. Mrs. H. Kröller-Müller's Collection, The Hague.*

they are alone, they move forward leaning on their feable strength with doubt and misgiving. If they write, they incessantly scan their own minds; if they paint, they incessantly scan their own faces, for they know that only in themselves will they find the opening of a clear path. And often, their fellow-men are frightened away and only come back later to worship their remains and their traces. This was Van Gogh's destiny.

By the end of this XIXth century which finally completed the failure of common convictions and left to his individual loneliness any man concerned about his fate and his reason for living, Van Gogh, man of passions and turmoil, could only live his venture by separating himself from the others and sinking into

*Peasant Woman Gleaning. Black pencil. 21" × 17" Nuenen Period, 1883-85. F. Jourdain's Collection, Paris.*

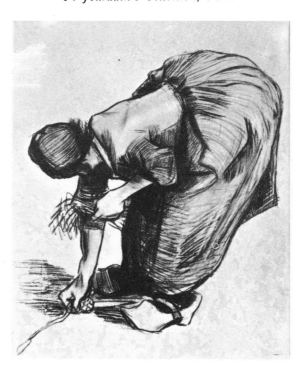

abjection and cannot stand it; he is conscious of this glory and cannot reach it. He understands what he would like to be and cannot understand what he actually is. His only reaction facing this unsolvable contradiction is a total numbness or a moral tearing apart and accompanying cries.

Van Gogh uttered one of the most violent of these cries, one of the most tragic, one of those « passionate sobs », mentioned by Baudelaire who considered them «the most certain evidence we can give of our dignity ». Sometimes, with this incentive, with a desire to free themselves and go beyond themselves, men set off in common: the hope of each is multiplied by the hope of every one; a religion is born. Then, sometimes

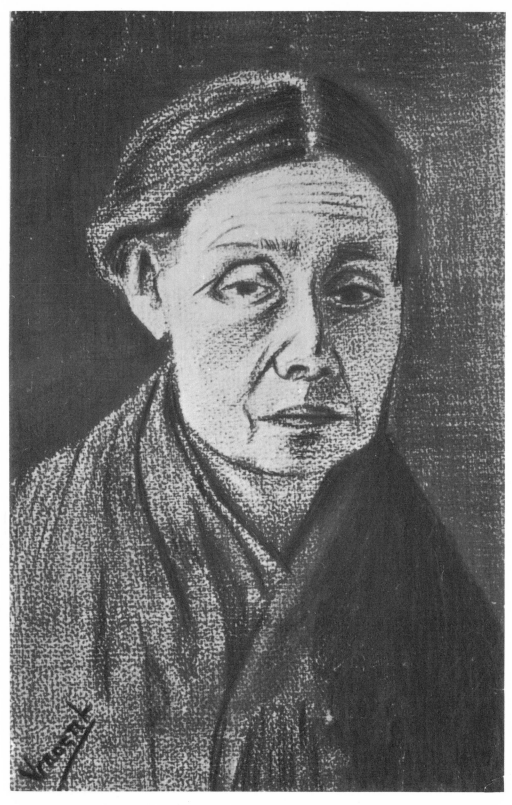

*Portrait of a Woman, Half-Length. Lead pencil and ink washing, 15½" × 10"*
*The Hague Period, 1883. V. W. Van Gogh's Collection, Amsterdam.*

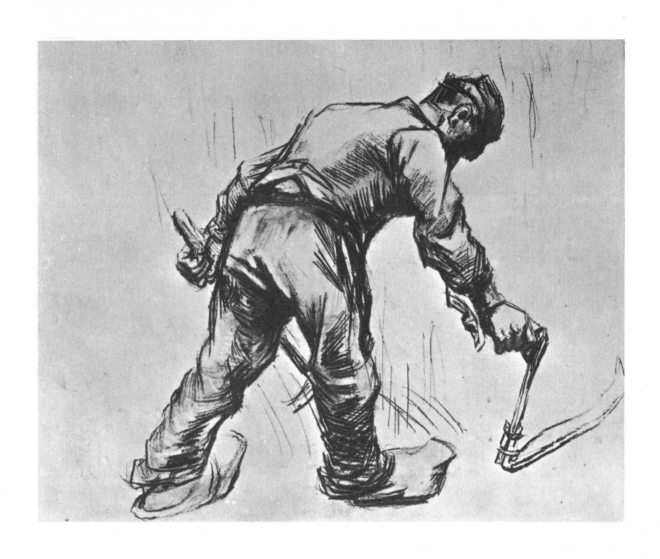

*Peasant Mowing. Black pencil. 16½'' × 20½'' Nuenen Period, 1885.*
*V. W. Van Gogh's Collection. Amsterdam.*

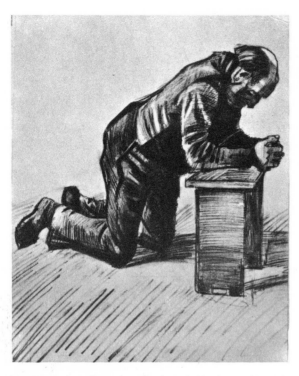

*Man Praying. Drawing, lead and black pencil with Indian ink touches. 22½″ × 18½″ The Hague Period, 1883. Franz Von Mendelssohn-Bartholdy's Collection, Grünewald.*

himself. Driven by his instinctive power, pushed by anguish, overriding his panic and his doubt by fiercely giving his whole being — with his hunted and angry eyes in a bony and hairy face — he was more than a painter expressing the terrible image of his soul; he was a mind, seeking his dreadful way with acts and words, with passion and nobility. His painting which seems to flow from him, violent and irresistible like an instinct was only, however, his last resort. It took him many a distressing experience before he realized that only when holding a paint-brush could he find, or hope to find, a way.

And as he fought with words he struggled with pictures! He is one of those artists whose writings should be dipped into at all time. His letters deserve a place beside the *Journal* of Delacroix. Their style may not be correct, first because any means of expression was a battle for him, but also because this Dutchman lived in France, used French most of the time and his normally entangled speech was still complicated by handling foreign words, belatedly learned. But this clumsiness itself gives a harsher and more heart-gripping tone to his questioning voice.

In his letters — the most beautiful and most important were addressed to his brother Theo who helped him all along his brief existence — he asks himself: « I always have the impression of being a traveller going somewhere, to some destination. If I say to myself: this somewhere, this destination does not exist, it seems to me to be true and well-reasoned. And at the end of my career I will be in the wrong: I will then find out that not only the fine arts, but even the rest were nothing but dreams and that one's self was nothing at all ».

Is life, then, definitely incomprehensible? Is there no glimmer in all this darkness? « So and so does not always know himself what he could do, but by instinct he feels: I am good at something. I feel there is a reason for my being alive... » There lies the way: « My torture is nothing more than this: In what way could I be good for something? Couldn't I help, be useful for something? » Not to know what to do, how to do it, nor what to expect from one's self! » I know that I could be an utterly different man. There is something inside me. What can it be? »

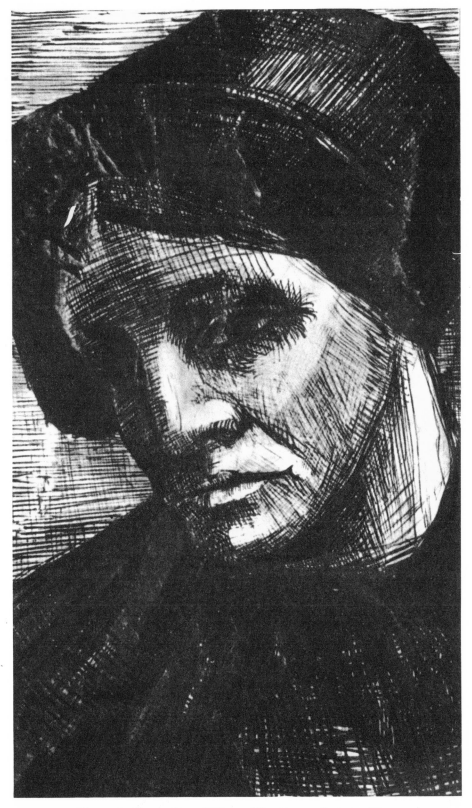

*Woman's Head. Pen. 8½" × 5 The Hague Period, 1881-3.*
*Hidde Nijland's Collection, The Hague.*

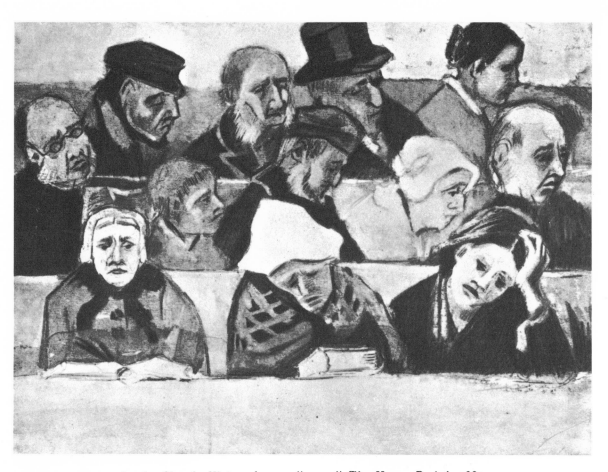

*In the Church. Water-colour. 11" × 15" The Hague Period, 1882.*
*Mrs. H. Kröller-Müller's Collection, The Hague.*

But is an act of faith of the soul enough? Yearning is no answer, it is only the desire of an answer. Before yielding to the answer, one must find it. So, this being, who is absolutely sincere, who is not satisfied with mere sentences, with fine words, who seeks like a blind man feeling his way with his fingers, but can then grasp what he finds, plunges his searching hands into the depths of himself. And what he first meets is something vague: a warmth. « I feel in myself a fire which I cannot let die out; on the contrary I must quicken it, although I don't know where this will lead me. » His mind still does not know towards what he is going, but he perceives a faint glimmer. He goes towards it and discovers a fire burning deep within himself, and this is already a certainty. There is a fire, and this fire must be used for something. It is not enough to have found it, it is not even enough to be burned out by it, this fire must have some sort of use; the problem is still there and he must start groping again to find another way. « It is like a great blaze in your soul, and nobody ever comes to heat himself by it. The passers-by just see a little smoke, there at the top, coming out of the chimney, and walk on. Now the question is, what to do? »

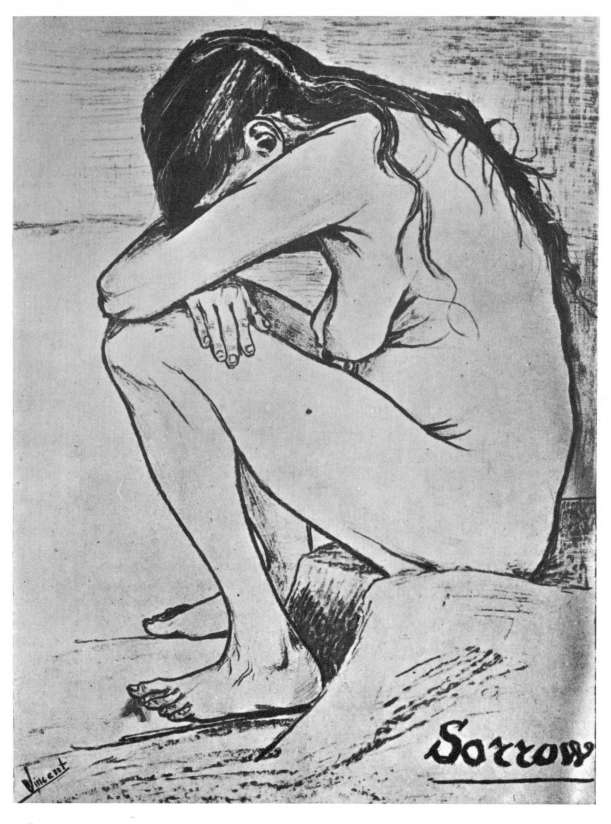

*Sorrow. Black Pencil. The Hague Period, 1882. Mrs. J. Van Gogh-Bonger's Collection, Amsterdam.*

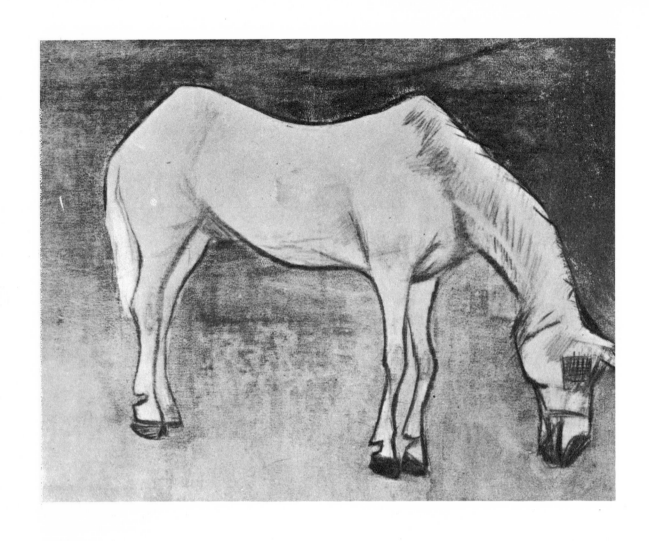

*The White Horse.   Black pencil and charcoal.   17" × 29½"   The Hague Period, 1883.*
*Prof. S. R. Steinmetz' Collection, Amsterdam.*

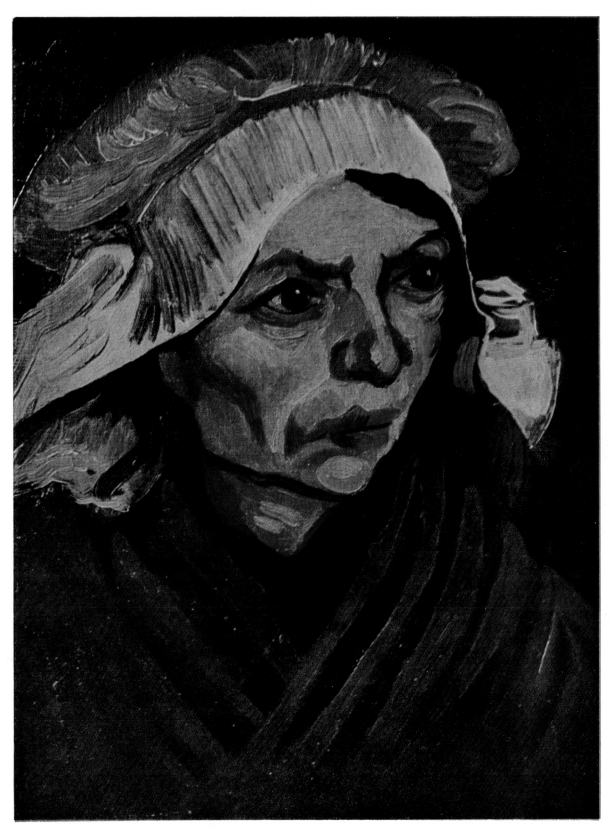

HEAD OF A PEASANT WOMAN.　Canvas, 16½"×12½"　Nuenen Period, 1885
Collection Dr. G. Schweitzer, Berlin

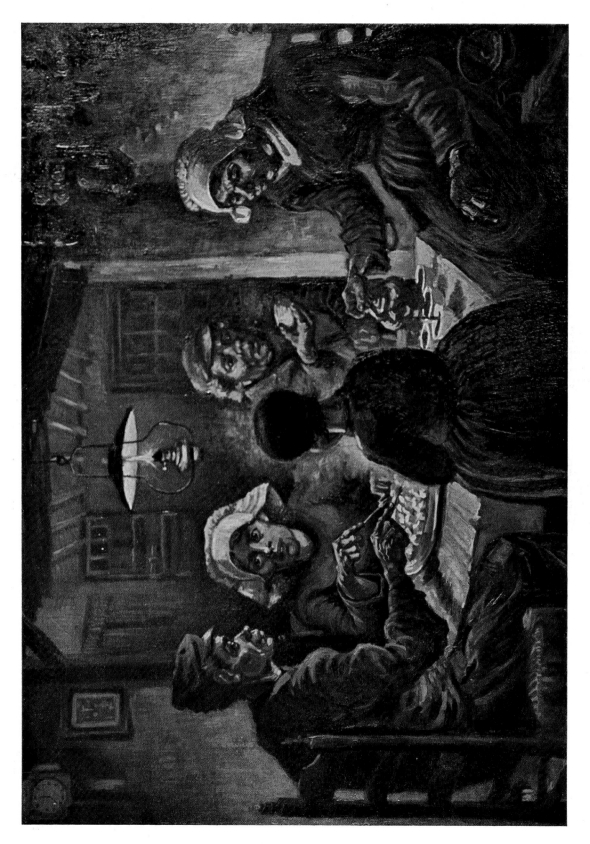

THE POTATO EATERS.   Canvas, 32½″×45½″   Nuenen Period, 1885
Collection V. W. Van Gogh, Amsterdam

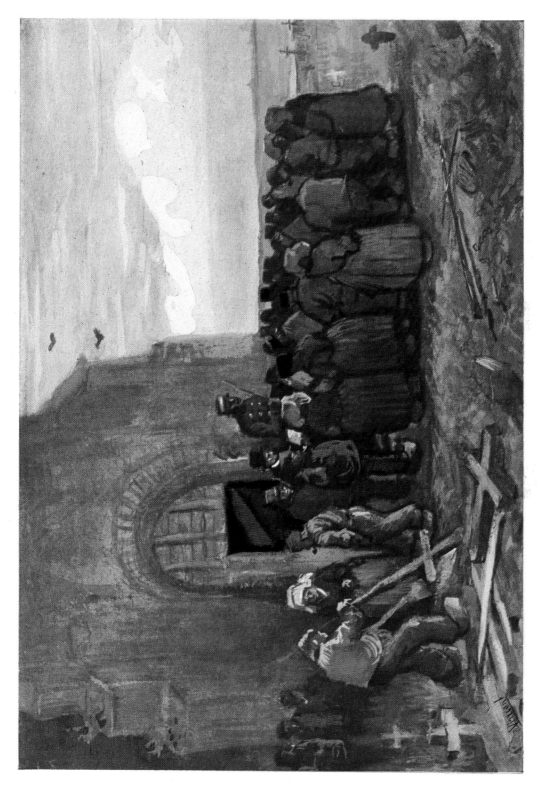

THE SALE OF CROSSES AT THE NUENEN CEMETERY.  Watercolor, 15"×22"  Nuenen Period, 1885
Collection V. W. Van Gogh, Amsterdam

THE WEAVER.    Watercolor, 14" × 10"    Nuenen Period, 1884
Collection V. W. Van Gogh, Amsterdam

Is it enough to be and to wait? « Keep this fire burning inside yourself, sense your own value, and yet wait patiently — oh how impatiently — wait, say I, for the time when somebody, anybody, will come and sit by the fire, will stay there, or do something? »

How significant is this mental image of a fire! It burns his mind and bursts out in his pictures. If — as Proust believed — each artist, each writer, can be summed up by a symbolical image, or even — according to Bachelard — by an « element » corresponding to his inner nature, Van Gogh can without doubt be interpreted by fire. In this, he brings to the mind another great Dutch painter, Rembrandt. But the latter saw the fire as a central brightness which pushed aside the heavy burden of darkness and where he could light the warm radiance of kindness. Van Gogh's fire is more terrible, more spasmodic, more consuming. It destroys as well as it quickens; it can be a sign of death as well as a sign of life.

Its flame dances; now it jumps up in a great blaze, now it fades and seems ready to go out. Then, Van Gogh loses again' the brightness he was following: « What good can I be, is his obstinate quest. What can I be useful for? There is something inside me. What, but what is it? ... men are often prevented from doing anything, prisoners of I don't know what horrible, horrible, most horrible cage! » From his pen flow out words which are almost Shakespeare's. « One cannot always say what shuts you in, walls you in, seems to bury you, but one feels nevertheless, I don't know what bars, what gates, what walls... and then one asks: my God, is it for long, is it for ever, is it for eternity? ». And thus goes on and on, in an unrelenting circle, the round of the prisoners, at the bottom of the dark pit which is their yard, enclosed on all sides by doorless walls. It is known that he painted this prisoners' walk under the shock he experienced on seeing a drawing of Gustave Doré, and one can guess the deep meaning which he immediately gave it: « This something which is called *the soul*, one claims it never dies and always lives — and seeks always, always, and again and always! »

First one must want and persist. « Where there is a will, there is a way ». « Even if I fall ninety-nine times, the hundredth I will get up once again ».

The circle turns and endlessly starts the same course over again. Why should it break? It is bound and limited by high walls. Thus reasons whoever only looks at his own level and straight ahead. But in the opening over and above the prisoners' walk a small patch of sky can be seen. Maybe it is enough to look above oneself? « You need something big, something infinite where you can see *God* ».

And just as Van Gogh found the fire, following Rembrandt's footsteps, he also discovered, like Rembrandt, what feeds it, what makes it shoot forth up to that little opening high above. Fire, by its human name is called love. And Van Gogh is perhaps the only painter, with Rembrandt, who based his whole art on love. He knows now how to call this blaze: It is the fire of love, the « fuego amoroso » which Saint John of the Cross had already revealed.

« Involuntarily, I always think that the best way of knowing God, is to love a great deal ! »

« It is good to love as much as one can, for there is the real strength, and one who loves a great deal achieves great things and is capable of it, and what is done through love is well done ».

During this too short life, Van Gogh will have the time to find out that good will and even love can go amiss.  He will fall on his knees several times; he will get up again, without surrendering.  He will then discover the meaning and the requirements of this fire and this love which are devouring him : «I cannot do without something which is greater than I, which is my whole life : the power to create».

The day he made this discovery, he became a painter.  But he still will have to discover, painfully, what is his painting, his real painting, the one he was made to paint.  And at that time, he will have about three more years to live...

This is the story that should now be told.  Vincent Van Gogh was born on the 30th of March, 1853, in Holland, at Grootzundert, in Northern Brabant.  He is a Northerner.  He does not come from those Latin countries where thought is the basis of harmony and equilibrium, organizing and regulating.  Of course, a man from the North is usually practical.  But as soon as thought starts seething in him, it adds a halo of uneasiness and perturbation to reality; it pushes reality away from any secure connection : the concrete.  Then man drifts away into the imaginary, he breaks the circle of security.  Thus starts the adventure of the unknown : he becomes a man possessed by the soul.

Furthermore, Van Gogh is a Protestant, a son and grandson of ministers, that is he comes from a religion whose straightness will not allow soft-hearted hesitations.  Let this soft-heartedness get loose, and it will also burn and destroy.  Rembrandt too, was a Protestant, but he could not have said, as Van Gogh did in 1877 : « As far back as one can remember there was always a servant of the Gospel in our family, from generation to generation ».

Nevertheless he seeks his way in another direction.  Like a premonition of his later destiny, but misdirected, he is attracted by art.  Of his three uncles, two were art dealers.  His idea is to do the same thing.  One of his uncles, who owned an art gallery in The Hague, had sold it to Goupil who was at that time owner of one of the main art galleries in Paris.  On July 30th, 1869, the Goupil Gallery in The Hague hires Vincent as salesman.  He is soon sent to their gallery in Brussels and in May, 1873 to the London branch.  There, the young man, who despite his middle-class origin had been a somewhat hunted looking youth, neglecting his appearance, aggressive and awkward, seems to accept the standards of life.  Like so many young men, despite all his smouldering inside passions, he seems to submit himself to a regular way of living.  Like so many young men,, he loves, he loves the first young girl he comes in contact with : she is the daughter of Van Gogh's landlady; her name is Ursule Loyer.  He asks her to marry him and is rejected.  He is in

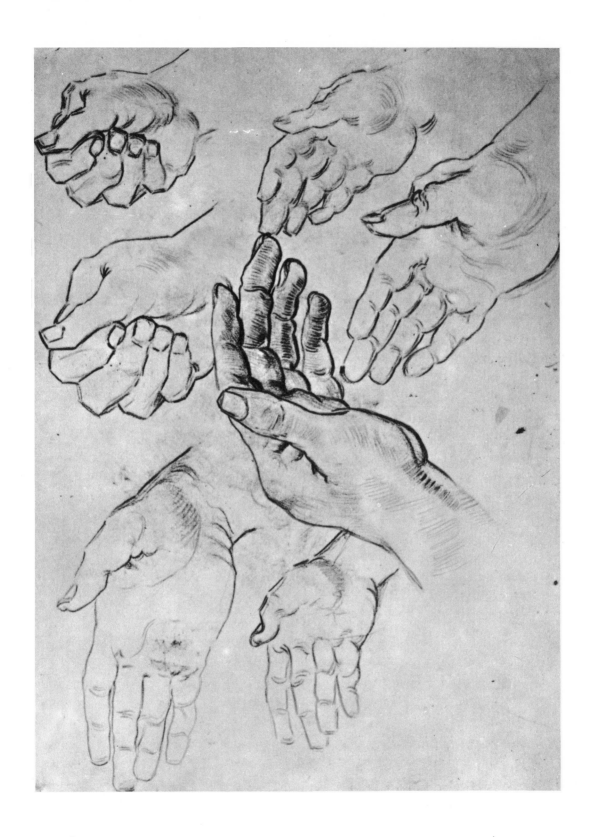

*Study Sheet With Seven Hands.  Black pencil.  13" × 10" Paris Period, 1886-88.*
*V. W. Van Gogh's Collection, Amsterdam.*

23

love, but he has not yet understood that love can only achieve its fullness through giving and not through greed. This failure, this first failure, heavily affects his hyper-nervous and unsteady nature, he sort of breaks down. He leaves London, comes to Paris, goes back to London, and finally in May, 1875 manages to get work at the Gallery Goupil in Paris.

In this center of intellectual effervescence, he starts escaping the limitations of his job: he visits the museums, grows enthusiastic at seeing the master-pieces, reads a lot, but as an auto-didacte. This is in 1875: the humanitarian idealism which soared up with the French revolution of 1848 has not yet seen the blaze of its generous illusions smolder down. Van Gogh is gripped by Dostiewsky and by Tolstoï. While in England, his reading George Eliot had somewhat prepared him for the Russian authors by setting his mind upon the sufferings of the humble. He finds this same accent of human generosity in Millet's paintings, and he will never cease to admire this artist. And finally, his atavism brings him to the Book among books, to the Bible. This will become his fundamental reading. And later on, the heavy volume, handed down from century to century, will take its place in his painting, as it had already been represented in many a painting from Rembrandt.

At that period a first mutation takes place: Van Gogh seems incapable of having normal social contacts; irritations, conflicts burst out and pile up. Hardly a year goes by before Goupil dismisses him. But his religious vocation is roused and he is going to follow it. He goes back to England and obtains a job as assistant teacher with a minister in Ramsgate. Entrusted with collecting the pupil's boarding fees in a miserable and popular district, he accomplishes this task as badly as possible and loses his job. He is again employed as teacher, by a Methodist minister and becomes, to use his own words: « something between a minister and a missionary ». Already, combining his religious heredity's call and his feeling for the humble, he applies for a position as evangelist among the miners. « I feel attracted by religion. I want to comfort the humble ». His request is not granted, because, so he is told, he is too young. So he goes back to Etten to spend Christmas 1876 with his parents.

Another commercial trial, as clerk in a bookshop in Dordrecht, doesn't last long. He believes he knows by now where his future lies: Religion is the opening he needs. But there too, good-will is not enough. He needs to expand his too superficial and too hasty education. Therefore he prepares himself to enter the Theological Seminary of Amsterdam. But how could he possibly conform to collective and regular methods of education? With a nature as tumultuous as his, he realizes he will never make it. He comes back to his family to brood over this new failure. Then, in August 1878, he makes a decision, goes to a school in Brussels where evangelists are formed and three months later he is called (his dream come true) to the most outcast, the most tragically miserable part of Belgium: the mining country, the Borinage. He first goes to Paturage, near Mons, then settles down in Wasmes. Feverishly he puts into action his idea of the pastorate. Impelled by his great feel-

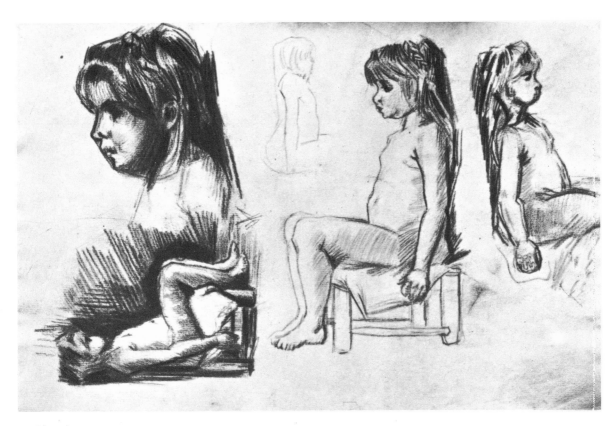

*Studies for a Nude Sitting Child.  Black pencil. 19" × 12½" Paris or Antwerp Period, 1885-86.*
*V. W. Van Gogh's Collection, Amsterdam.*

ing for poverty, he thinks the times of Saint Francis of Assisi, or the times of
Christ are not so obsolete and that religion can be brought to the poor by putting
oneself on the same level of destitution: he dresses like a miner; he lives in a wooden
shack, sleeps on a pallet covered with pieces of old coats; he cuts out his puttees
of coal sacks and, blackened with the mine's dust, he tries to lead the same life
as the colliers and show them that he is one of them.

It was with deep emotion that I held in my own hands the Bible of Van Gogh,
the evangelist!  It was loaned to me by a Swiss minister who had been fortunate
enough to collect it!  Van Gogh had underlined in the margin the parts which im-
pressed him most: the most dramatic, the most terrible, the most desperate.

Pharisees are of all times: Van Gogh's superiors do not appreciate this great
drive of his.  Just like with Saint Francis of Assisi a scandal results.  Very soon
he is dismissed, no doubt politely and courteously, but definitely.  He is told that
he lacks perhaps the eloquence indispensable to his profession...

* * *

After the failure of individual love, which marked him so deeply when he was
in England, he now has to face the failure of collective love, of love for mankind

by means of the Scriptures. There we may be touching the core of the crisis which Van Gogh lived and which we are still living. The crisis of our time is no doubt the crisis of individualism which cannot be solved simply — as some new form of civilisation proposes — by replacing it by collectivism. In a way, the birth of Protestantism is already the consequence of occidental man's evolution towards individualism. But the latter, born at the end of the Middle Ages, undoubtedly received from the reformed religion a new stimulus which strongly helped its expression. Before that, man had formed the habit of only considering himself in connection with society; he could not imagine himself distinct from society. Thus, during the Middle Ages, it took very exceptional circumstances for an artist even to think of losing his anonymity and sign his own name to his works! He felt he was a good worker in a great collective effort which was the work of humanity in his time.

Since his beginning, had man ever ceased to exist within a social concept, expressed especially by religion? The first attempt to escape had been made by the Greeks who asked for the recognition and expansion of the individual, but that had sunk with the decadence of Rome. Catholicism had sealed the unanimous conscience with a new cement. Isn't that what Claudel means, when speaking of Rubens, Flemish Catholic of the Counter Reformation whose work is of such a large generic nature, he says: « It is with his whole work that we pray God, for the Protestant prays alone, but the Catholic prays in the *Church's community* ».

And it is a fact that already, during the same century, but in Protestant Netherlands, Rembrandt challenged this humanistic and collective nature and offered a vision of the sacred writings born from his most personal dreams. He incarnates the old Huguenot saying: « His Bible in his hand, a Protestant is a small pope... » as opposed to the communion of the Catholic church (*église* in French, as derived from « ecclesia »: assembly).

Confronting a religion which integrated each of its followers in general prayer and whose cult by its involved pomp aimed to exalt the conscience of a common soul, Protestantism sets up the individual, naked and alone, face to face with his personal responsibilities. The Catholic prays in Latin, but the Protestant seeks a direct and controlled contact with the Scriptures in his own language. He then ineluctably finds himself alone facing his own conscience. Thus was hastened the passage from a humanistic to an individualistic culture which attained its most acute form with the XXth century.

Does anybody ever stop to think that the idea of originality, which for us has become the basis of any creative value in art or literature, was almost unintelligible during past centuries? But at the same time that the XIXth century man acquires this new conscience of originality he has to pay for it by accepting the conscience of loneliness and its heaviness. Starting with Chateaubriand, starting with romanticism, the individual wanting to conquer his independence and refusing to owe anything to anyone but himself, is without protection and finds himself facing the uni-

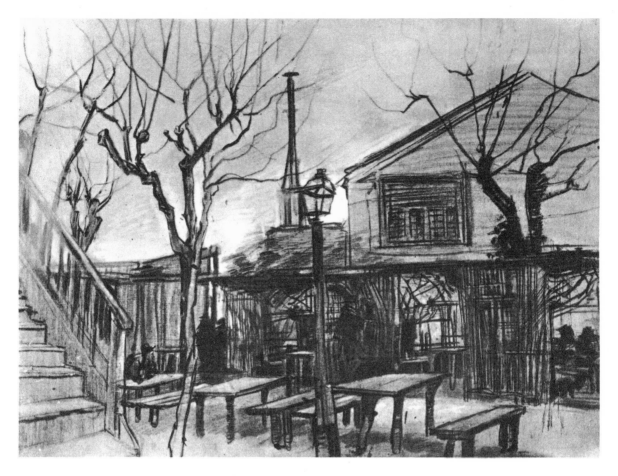

*The « Guinguette ». Pen, lead pencil, touched up in white. 15" × 20" Paris Period, 1887.*
*V. W. Van Gogh's Collection, Amsterdam.*

verse alone. All that is left is the Me and Not-Me; Me and the Other. These expressions will become familiar to philosophies. This is when the tragedy arose — which had been brewing since the XVIIth century, since Pascal had first wavered between an original, strong and absorbing individualism and the Christian and Catholic collectivity in which he found a prop and a exorcism against his bewilderment.

Van Gogh belongs to this end of the XIXth century where the crisis arrives at its culminating point. Creative individualism becomes aggressive and anti-social. With Rimbaud's generation it becomes revolt and rebellion.

But if the *Bateau Ivre* can sail fervently towards unknown navigation, and if Van Gogh is in many ways close to Rimbaud's flamboyance, we must not forget that Van Gogh is a Protestant and therefore thrown into the same inner conflict which Gide will know later on, with, however, quite different consequences. But this retiring into oneself goes along with a feeling of moral culpability. Because when the

Protestant automatically develops in himself an individual feeling, he is morally aware, at the same time, of the scruples of this feeling. He has favored the « go » but he has understood the danger of it; his stern conscience is worried about the expansion of this ego which has no other control left than himself and which therefore must be all the more on the look-out, all the more unrelenting towards itself. This germ of discord which in another person would resolve itself into scruples, becomes for Van Gogh a heart-break: he knows simultaneously the maximum of the ego's exaltation and the maximum of the ego's scruples. It is from this that he acquired what would be called today a failure complex. Giving himself frantically

*Nude. Lead pencil. 10" × 12½ "Paris Period. V. W. Van Gogh's Collection, Amsterdam.*

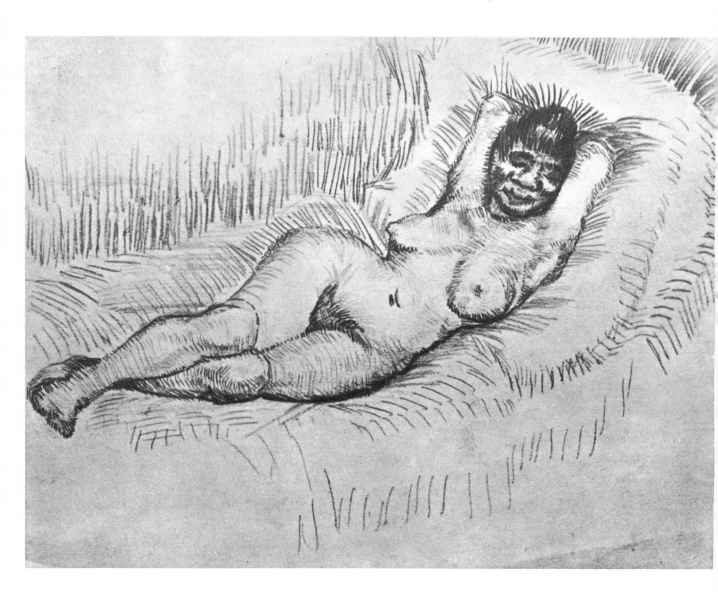

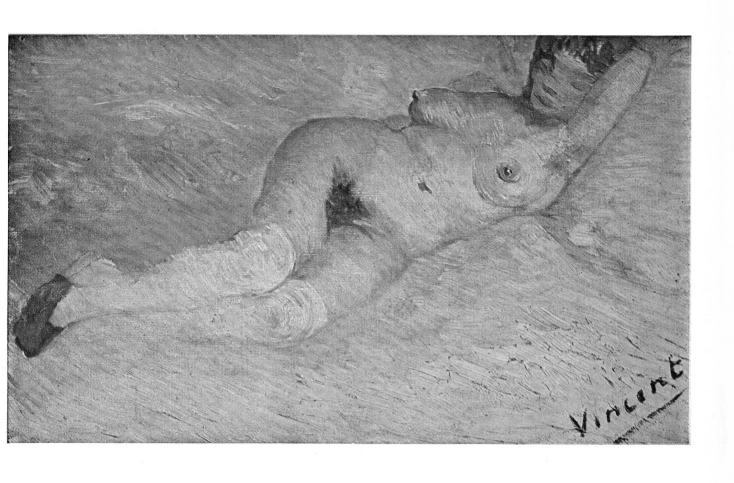

NUDE WOMAN RECLINING.   Canvas, 9½"×16½"   Paris Period, 1887
Collection S. van Deventer, Wassenaar

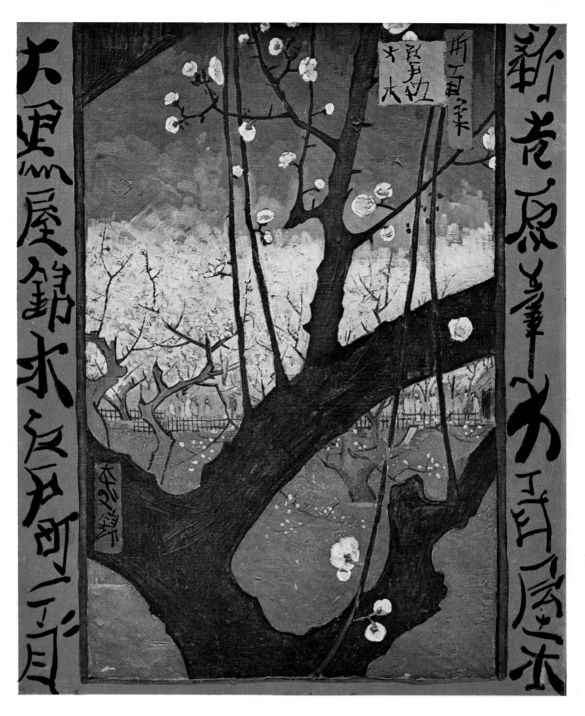

«Japonaiserie» The Tree (After Hiroshighe).   Canvas, 22½"×18½"   Paris Period, 1886
Collection V. W. Van Gogh Amsterdam

«Le Père Tanguy».   Canvas, 25¾"×19¾"
Paris Period, 1887.   The Niarchos Collection

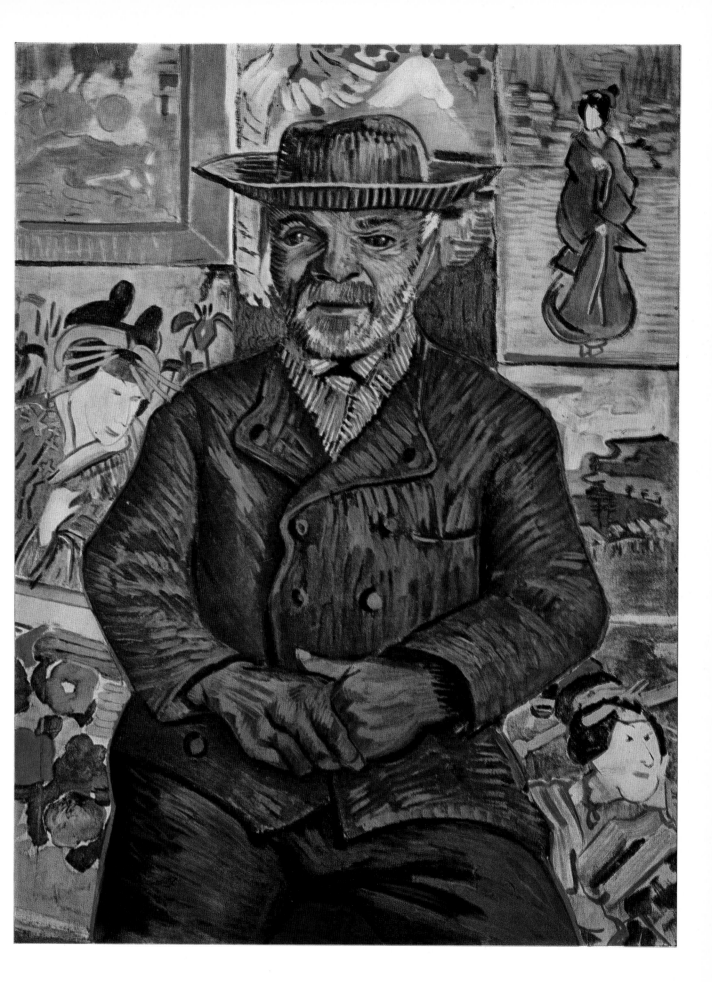

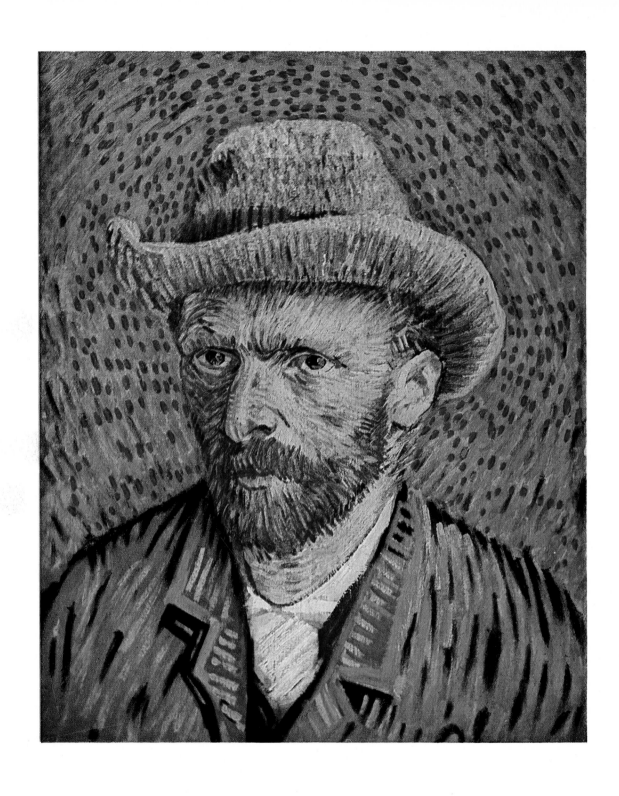

SELF-PORTRAIT. Canvas, 17½"×15"  Paris Period, 1887
Collection V. W. Van Gogh, Amsterdam

to the most intimate and most valuable part of his individuality, he is bewildered by his responsibility.

When an individual becomes so centered upon himself, his balance requires that he catch up with the others and with God through an action which springs from within him and which is love: « God is love... » The Protestants incessantly state. Alexandre Vinet, a Swiss theologian and one of the most eminent Protestant thinkers of the first part of the XIXth century, worded thus this doubt: « man master of himself so as to be a better servant of all? » This is really the problem of conscience which Van Gogh, after Rembrandt, transposes into artistic creation. He vehemently wants to be himself in a brutal and uncompromising way, even if he clashes with social constraint, but he sets one condition for himself: to be a better servant of all. His excessive ego is burned by a craving to *give*. His whole life is built upon an exaltation of his ego, which brings about an anguish of the ego, which in turn brings remorse of the ego and which finally leads to the redemption of the ego through an act of love.

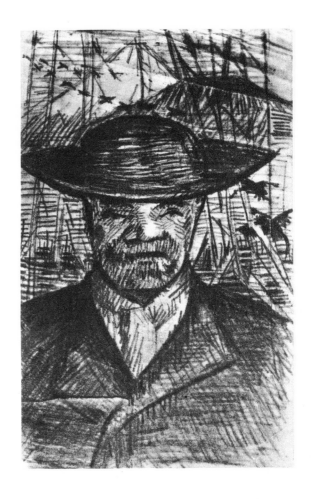

*Old Man Tanguy. Lead pencil. 8½'' × 5''*
*Paris Period, 1887.*
*V. W. Van Gogh's Collection, Amsterdam.*

\* \* \*

However, Van Gogh is not yet sure of the best way to shape this act of love. After the failure of his evangelistic attempt in 1872, he passes through one of the darkest periods of his life. He begins to grasp the idea of a solution through art; he makes his first friends among painters: Van Rappard, whom he meets in Brussels in 1880, Anton Mauve, his cousin who agrees to guide his first steps in The Hague in 1881.

But Van Gogh, discouraged by religion, tries to come back to the love of one being: during his stay with his parents in 1881 in Etten, he asked for his cousin's hand and only obtained a miserable refusal which separates him from his family. At this time, at the beginning of 1882 in The Hague, he asks for nothing more and

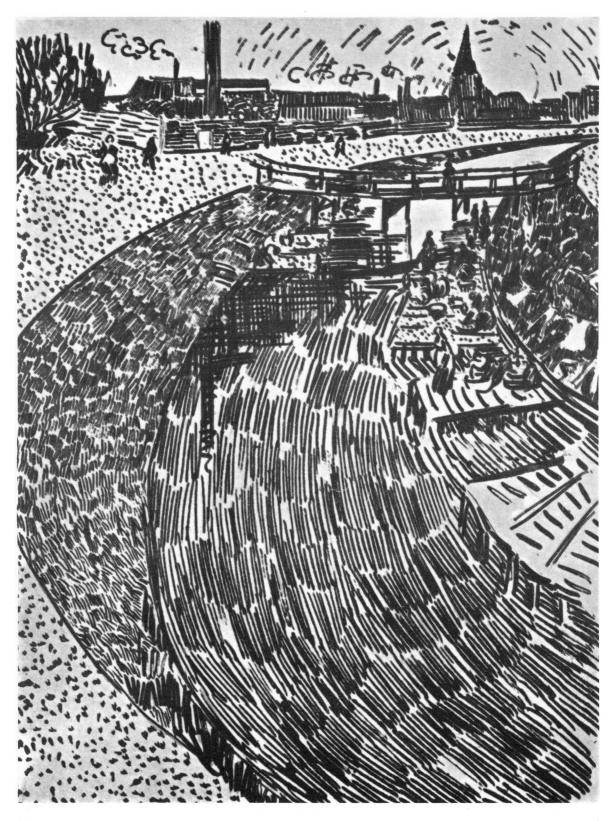

*The Washerwomen. Pen, reed. 12½" × 10" Arles Period, 1888. Kröller-Müller Museum, Hoenderlo.*

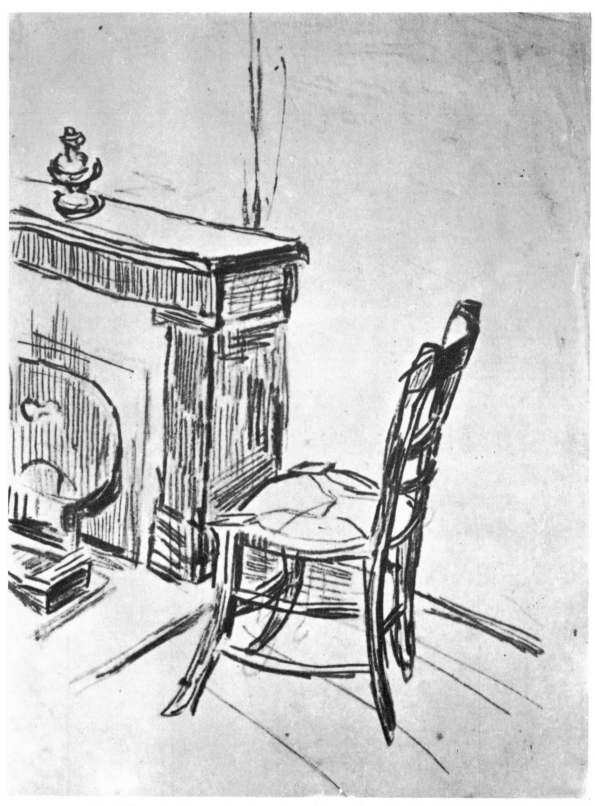

*Chair Near the Stove.  Lead pencil.  13" × 10"  Arles Period, 1888-89.*
*V. W. Van Gogh's Collection, Amsterdam.*

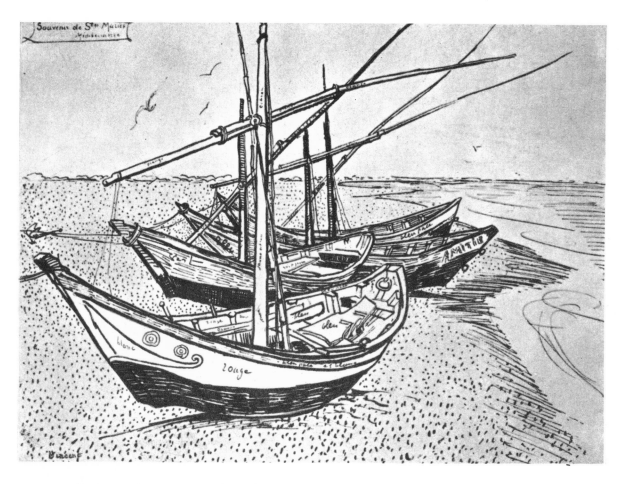

*Study for the Boats at Saintes-Maries.   Drawing.   16" × 21½"   Arles Period, 1888.*
*Tschudi Collection, Munich.*

attempts to go to the ultimate of what he considers giving of himself.  He chooses the most miserable woman he can find, the most loveless and probably the most worthless, a street girl, a drunkard, ugly, mother of five children, a woman called Christine.  Undoubtedly influenced by the memories of the novels of Dostoievski and Tolstoi he picks her up in the gutter and, disregarding both the laws of men and morals, he takes care of and lives with her for twenty months.  This is another failure.

But before leaving Christine, he takes her as the pitiful model for a lithograph made in 1882 and which he calls « Sorrow »...  A naked woman, sitting with flabby breasts, heavy stomach, thin and stiff hair, and weeping with her head on her knees.

More and more Van Gogh is under the impression that art could be the eagerly desired solution.   Isn't it precisely the richest and most complete expression of the ego, but sought through work, and often through suffering, so as to enrich others by its presence.  Through painting Van Gogh can become an egoist, but in the purest sense of the word, the sense Barrès gave to egotism.  He will give him-

36

self to his ego, he will let himself be possessed by it, but only to draw out all the riches it contains. He cuts out from his bleeding personality the pound of flesh which he intends throwing out to feed the others. The equation is resolved: exaltation equals giving. But as nothing must be easy for him, he will have to plow deeply and for a long time this barren field before the first green sprout, the one which will bear flowers, bursts from this torn soil.

* * *

Van Gogh belongs to the family of the seers, of the greatest poets, of the greatest painters. For them the false antagonism which our times has planted between the abstracts and the figuratives does not exist. The seer no longer registers reality as a mere show, by looking mechanically, as most men do. Beyond the sensory aspect of things which satisfies the positive vision, he can perceive what they mean, that is, what they are. This gift, which was mere instinct before, has become conscious

*Bridge on the Rhone. Pen. 10" × 12½" Arles Period, 1888-89. J. Hessel Art Gallery, Paris.*

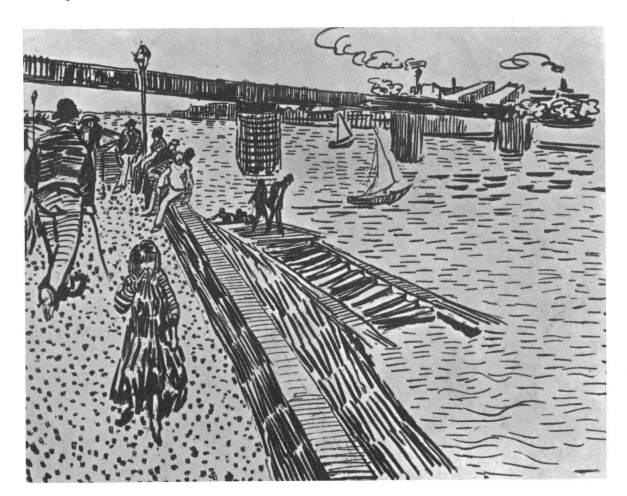

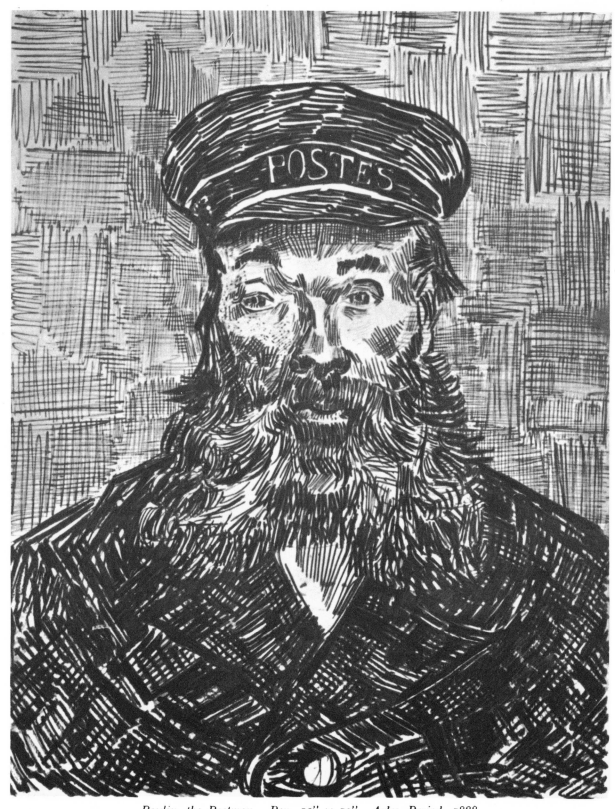

*Roulin, the Postman.   Pen. 13" × 10"   Arles Period, 1888.*
*Dr. A. Hahnloser's Collection, Winterthur.*

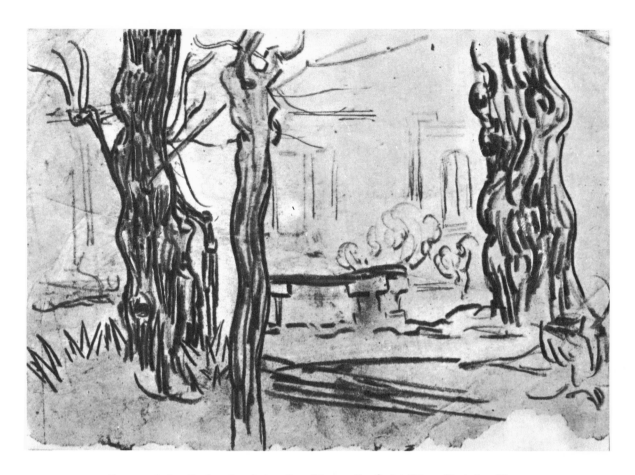

and has been cultivated since Baudelaire; the symbolists, where Van Gogh belongs, made it the basis of art. One knows, now, that any reâl artist *chooses*, without even knowing it, among all the things which life shows and brings, only what a secret correlation connects with his own nature. Objects are no longer solely a story, a thing passing in front of his eyes by chance; he watches out, he listens to a harmony, to a vibration, wherein he recognises himself, where often even he becomes clearer, and which, underlined, freed, brings to others the echo of what vibrates in his sensibility.

With Gauguin who announced « the musical part which colour will now have in modern painting », Van Gogh will soon be prophetising: « painting, such as it is now, promises to become more subtle — more music and less sculpture — and especially it promises colour ». It is colour — « a vibration as is music » writes Gauguin in 1899 — which he will mostly use during his last years to project into the sensibility of others. His own sensibility perceived it by watching the world. He explains in 1888 to his brother Theo that he wanted to « express the love of two

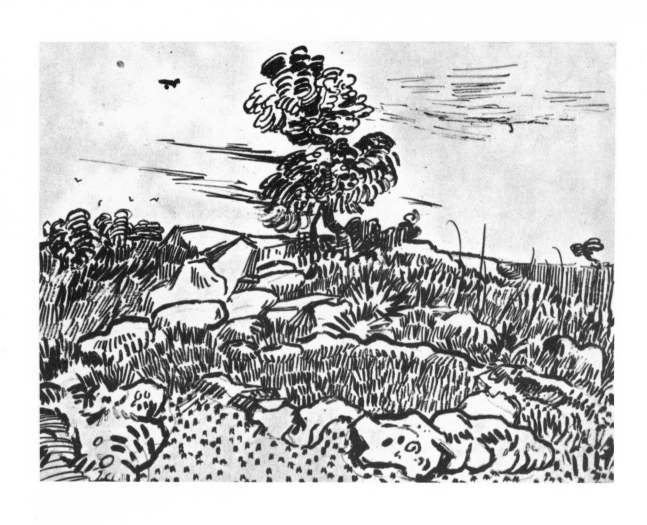

*Rocky Ground. Pen, reed. 10" × 12½" Saint-Rémy Period.*
*Dr. G. Schweitzer's Collection, Berlin.*

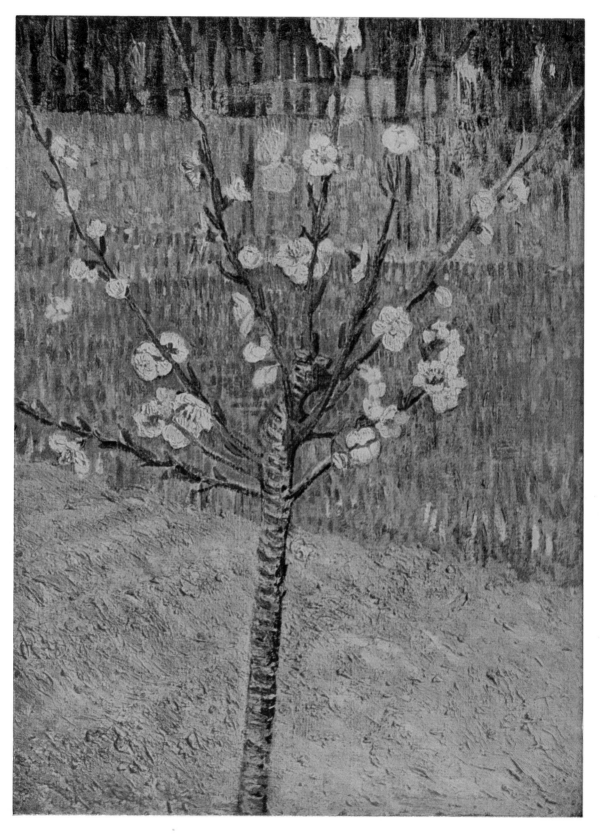

THE PEAR TREE IN BLOSSOM.  Canvas, 20½" × 15"  Arles Period, 1888
Collection V. W. Van Gogh, Amsterdam

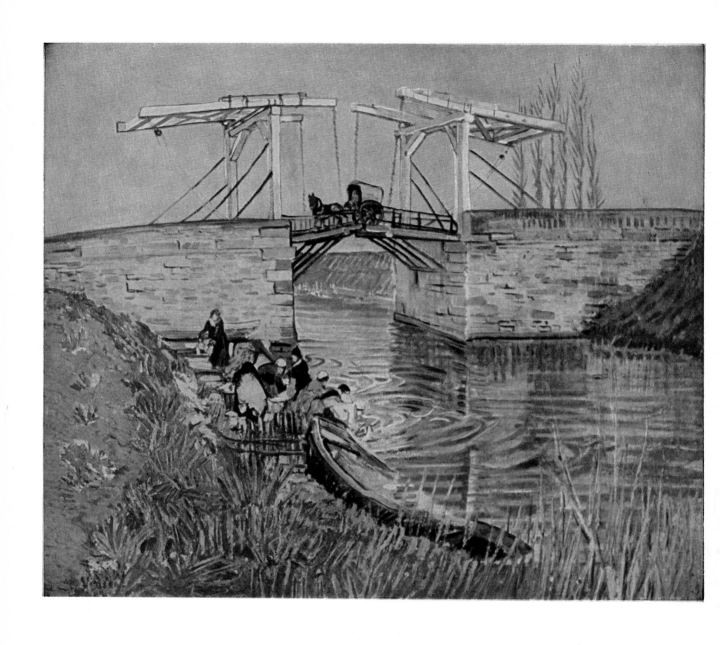

THE ANGLOIS BRIDGE. Canvas, 23" × 24" Arles Period, 1888
Gallery G. Wildenstein, New York

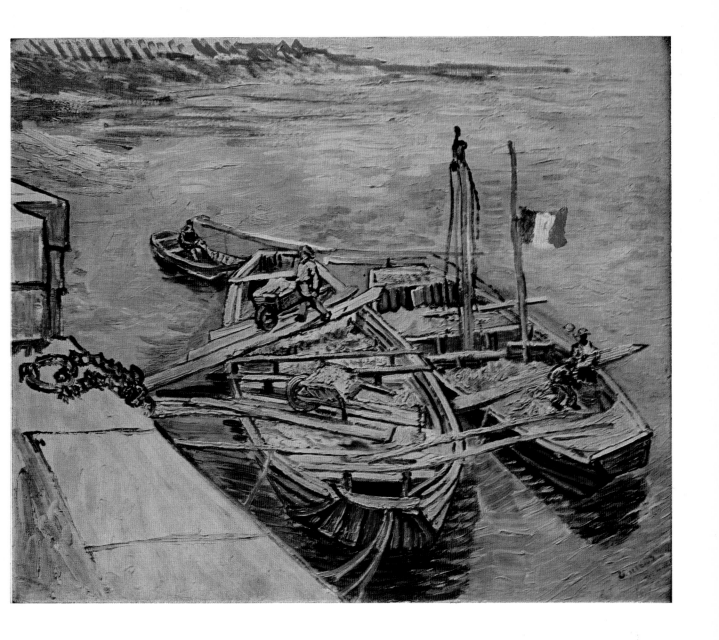

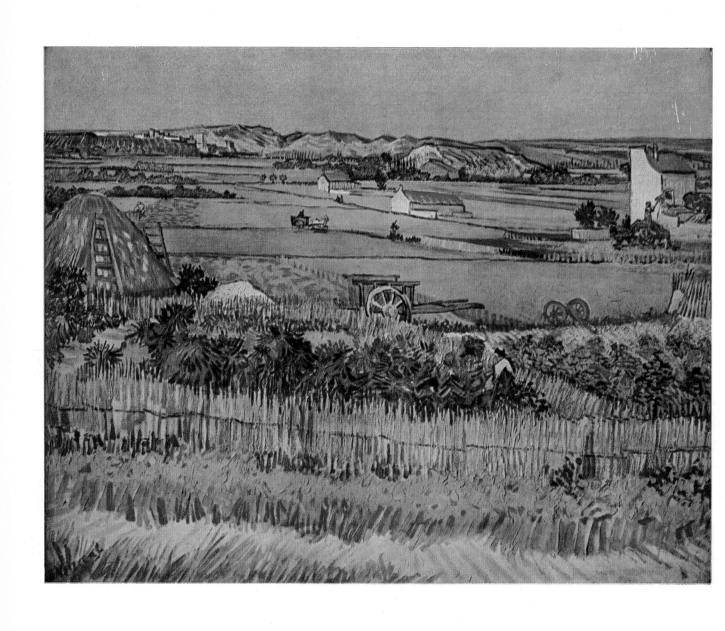

MARKET GARDENS.  Canvas, 29" × 36"  Arles Period, 1888
Collection V. W. Van Gogh, Amsterdam

44

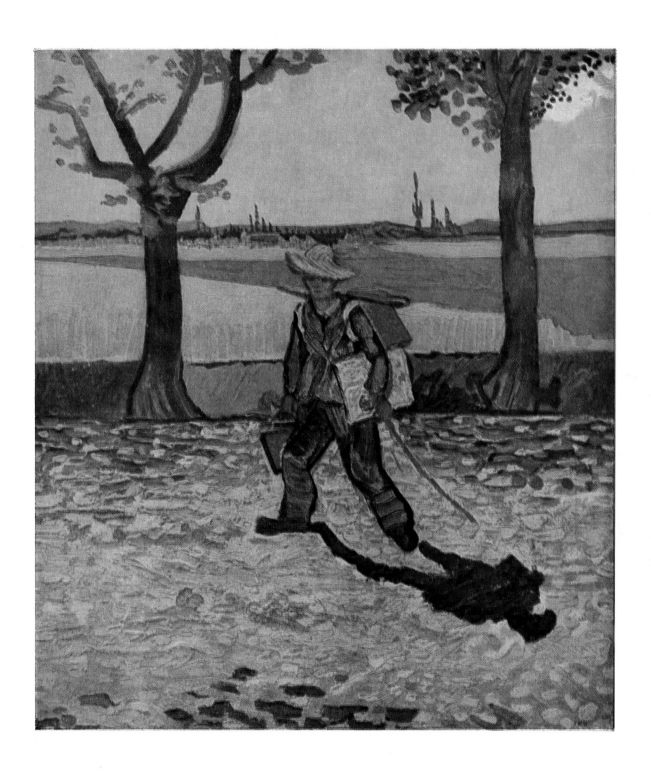

THE PAINTER ON THE ROAD TO TARASCON. Canvas, 19¼" × 17" Arles Period, 1888
Kaiser Friedrich Museum, Magdeburg

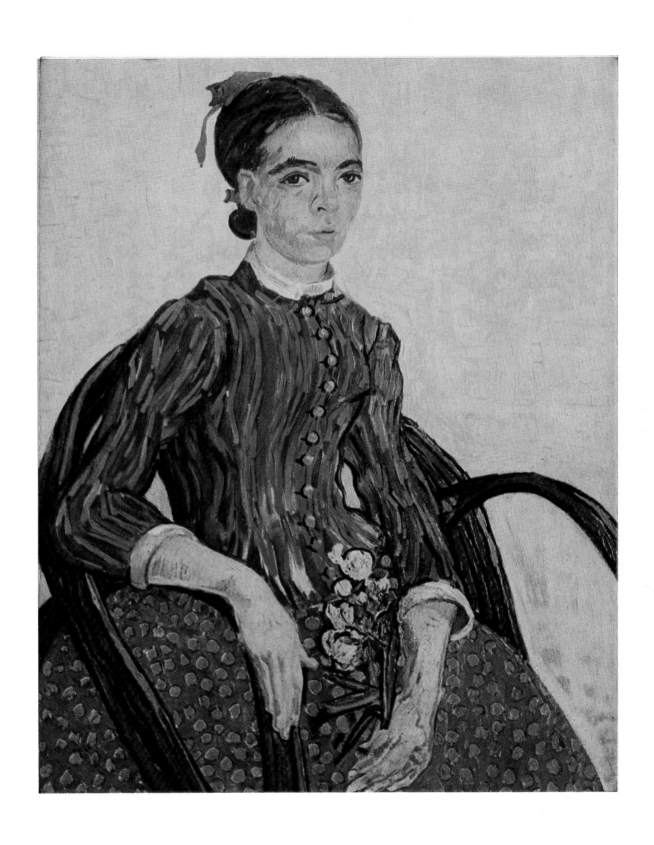

« La Mousmée ».  Canvas, 30" × 24"  Arles Period, 1888
Collection Chester Dale, National Gallery of Art, Washington, D. C.

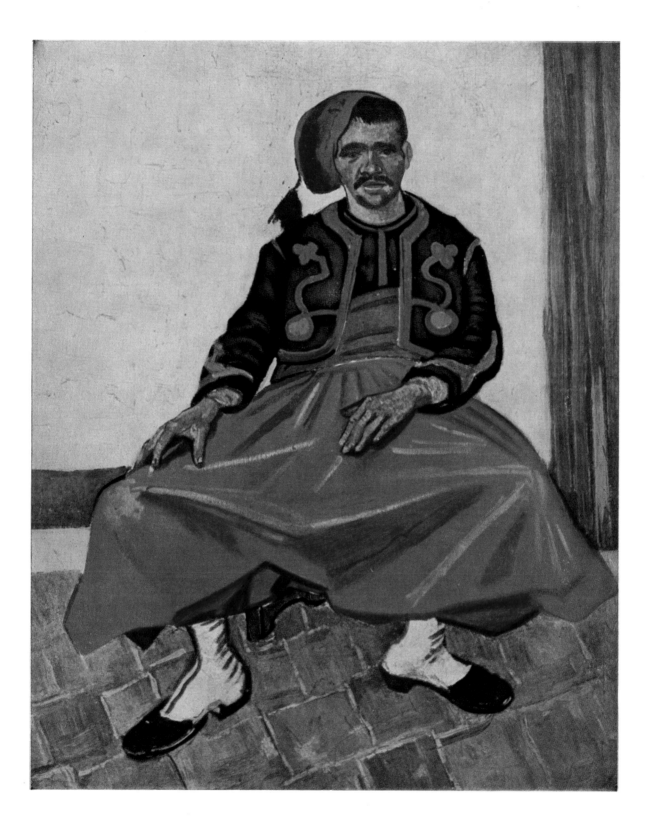

THE ZOUAVE.  Canvas, 32½" × 26"  Arles Period, 1888
Collection A. van Hoboken, Vienna

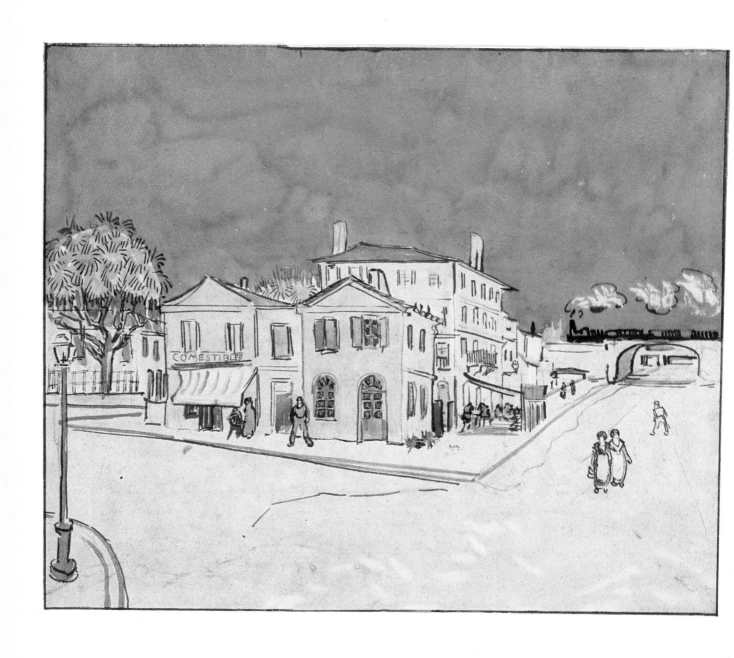

STUDY FOR VINCENT'S HOUSE IN ARLES. Watercolour and cane, 10" × 12". Arles Period, 1888
Collection V. W. Van Gogh, Amsterdam

48

A WALK IN ARLES.  Canvas, 29 × 36½"  Arles Period, 1888
Ermitage, Leningrad

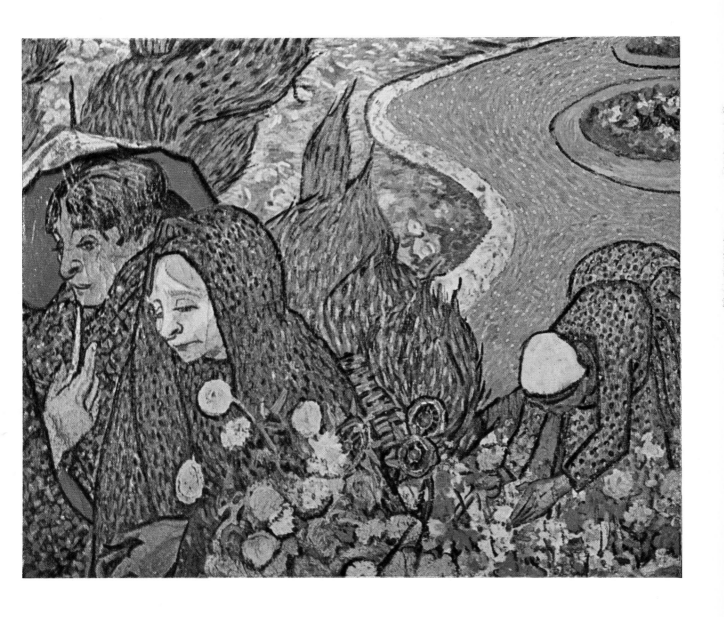

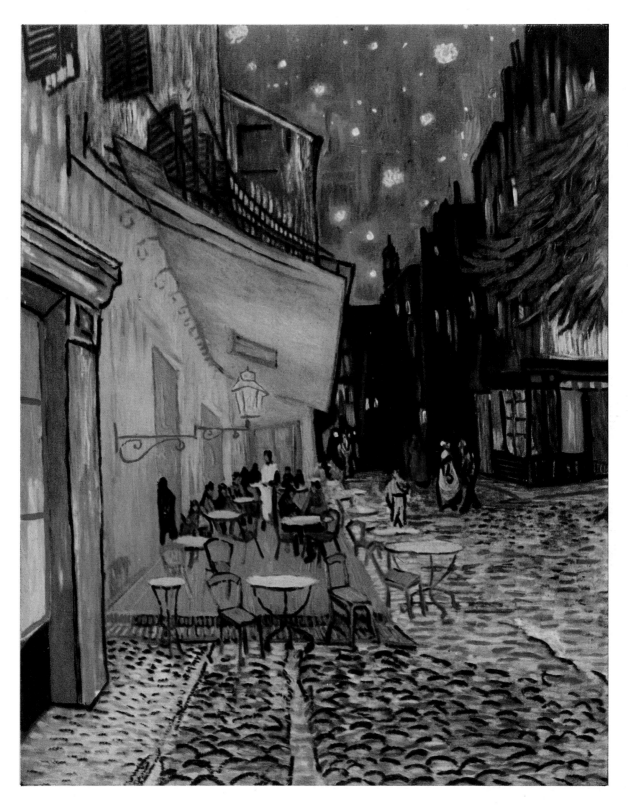

THE CAFÉ AT NIGHT.  Canvas, 30½" × 25¼"  Arles Period, 1888
Kröller-Müller Museum, Hoenderlo

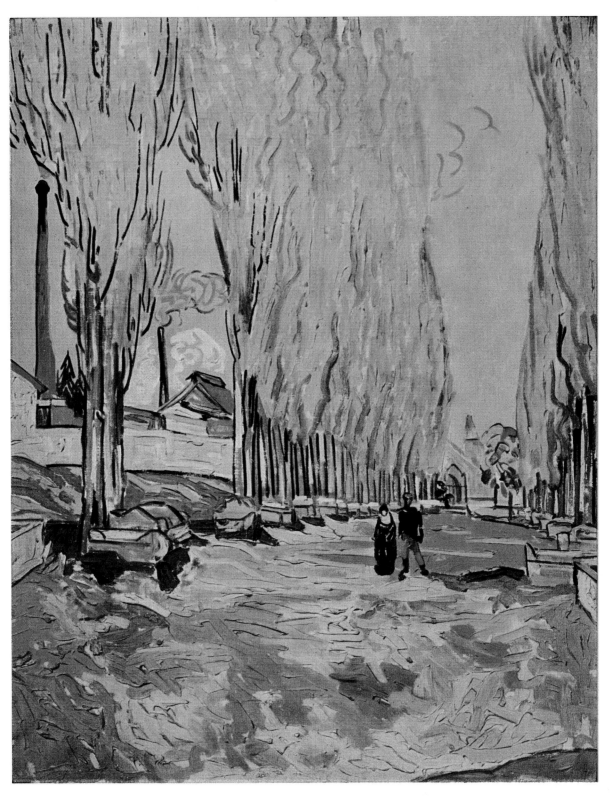

« LES ALYSCAMPS ». Canvas, 35½" × 29" Arles Period, 1888
Collection Bernheim Jeune, Paris

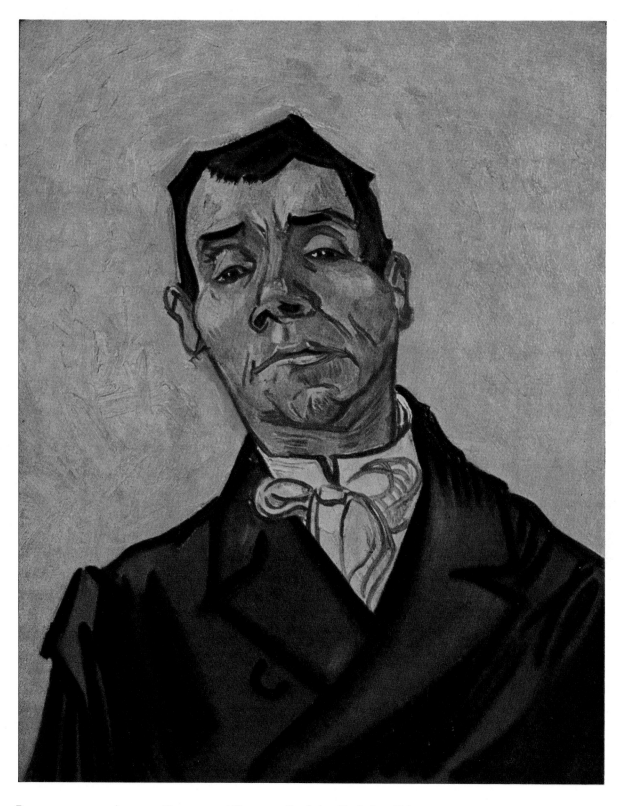

PORTRAIT OF AN ACTOR.  Canvas, 25¼" × 20½"  Arles Period, 1888
Kröller-Müller Museum, Hoenderlo

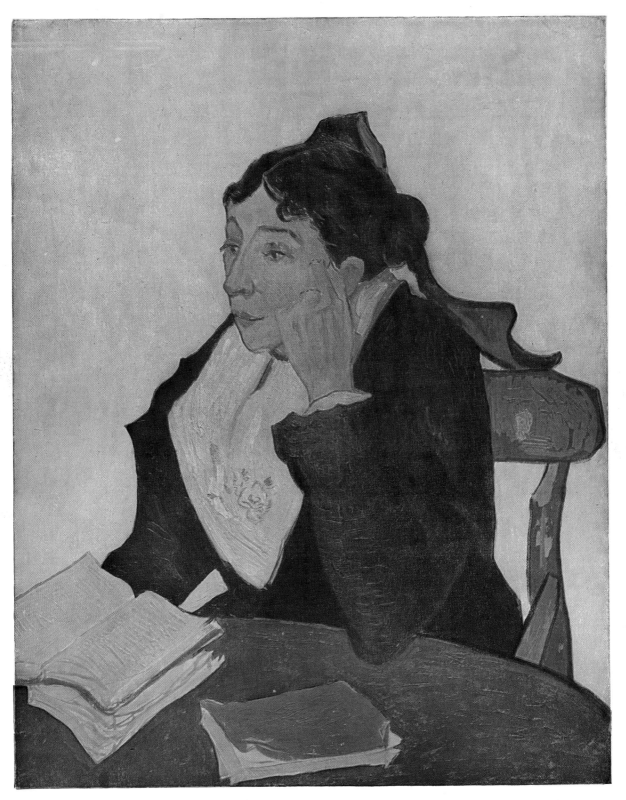

« L'Arlésienne » (Madame Gignoux).   Canvas, 37" × 20½"   Arles Period, 1888
Metropolitan Museum of Art, New York

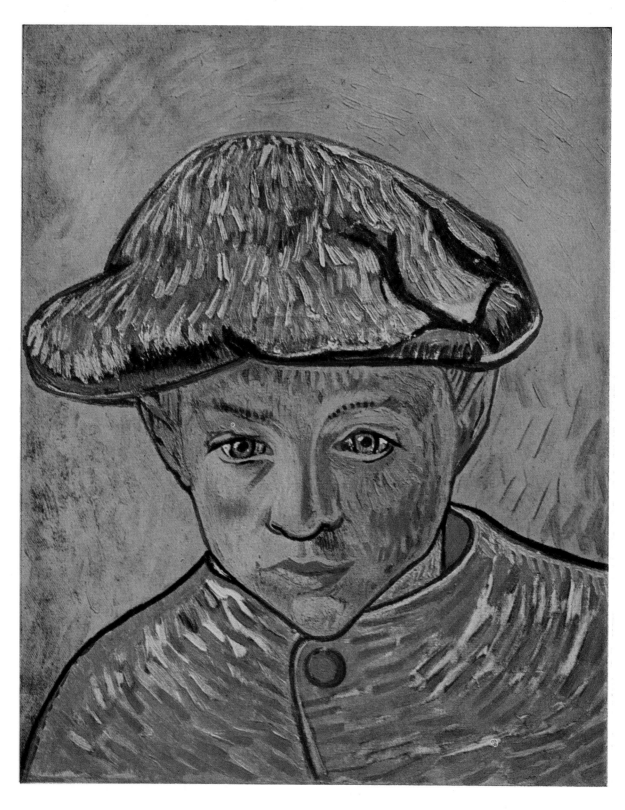

CAMILLE ROULIN. Canvas, 15" × 13" Arles Period, 1888
Collection V. W. Van Gogh, Amsterdam

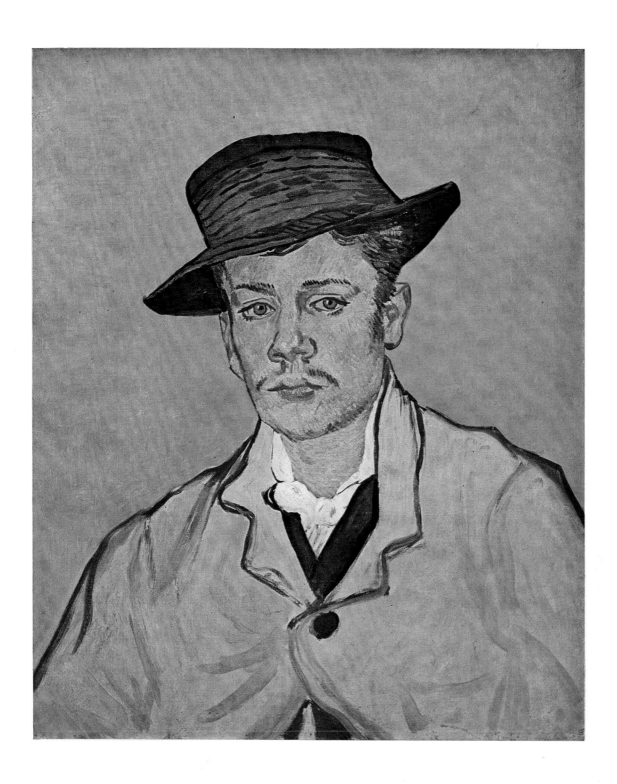

PORTRAIT OF ARMAND ROULIN.   Canvas, 26" × 21 ½"  Arles Period, 1888
Collection Folkwang Museum, Essen

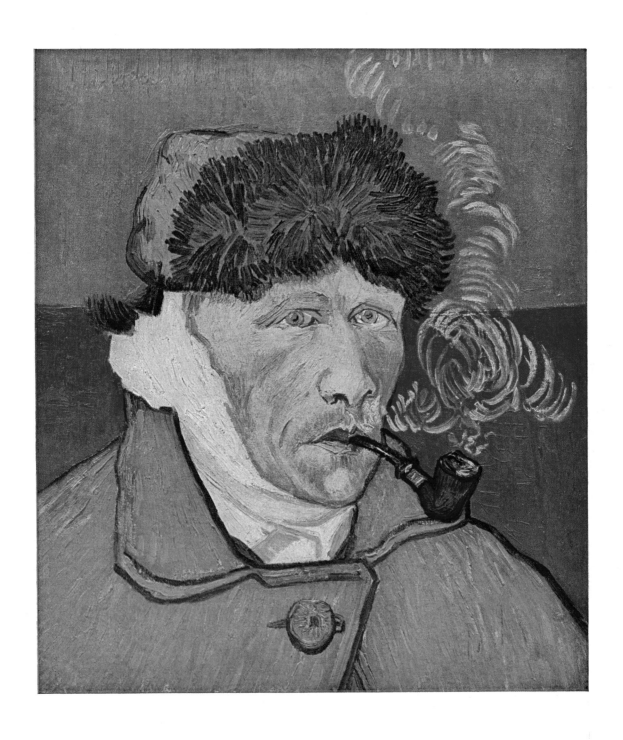

PORTRAIT OF THE PAINTER WITH A PIPE. Canvas, 20½" × 18"  Arles Period, 1889
Collection Mr. and Mrs. Leigh B. Block, Chicago

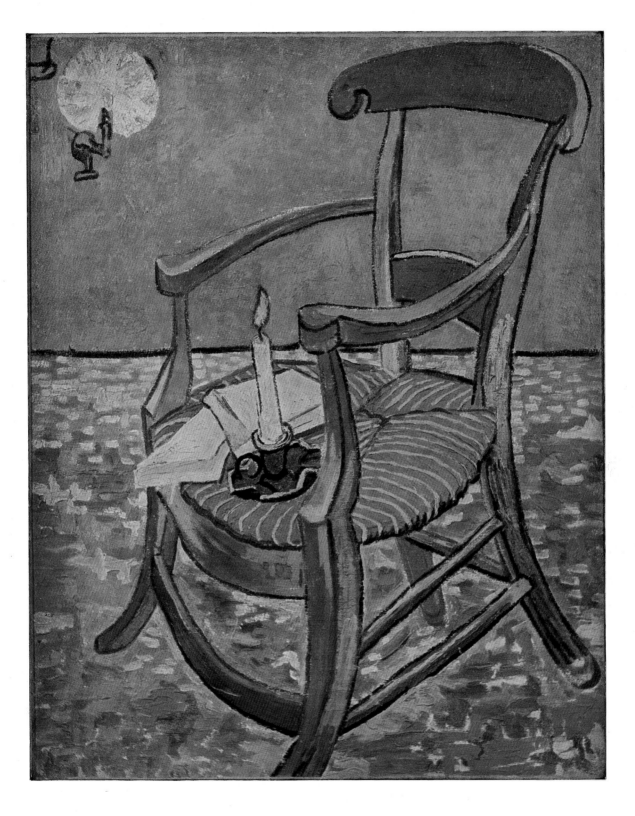

GAUGUIN'S ARMCHAIR.  Canvas, 36" × 29"  Arles Period, 1888
Collection V. W. Van Gogh, Amsterdam

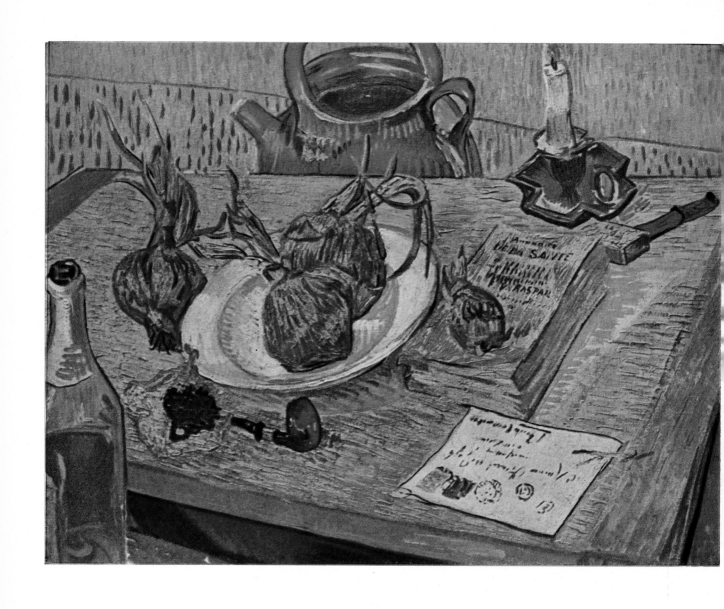

Still Life: Drawing Board with Onions, etc.   Canvas, 20" × 27"   Arles Period, 1889
Kröller-Müller Museum, Hoenderlo

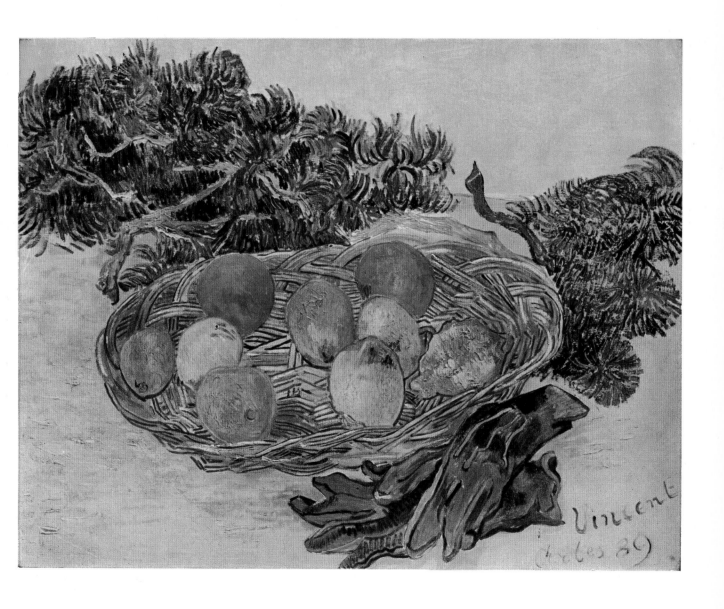

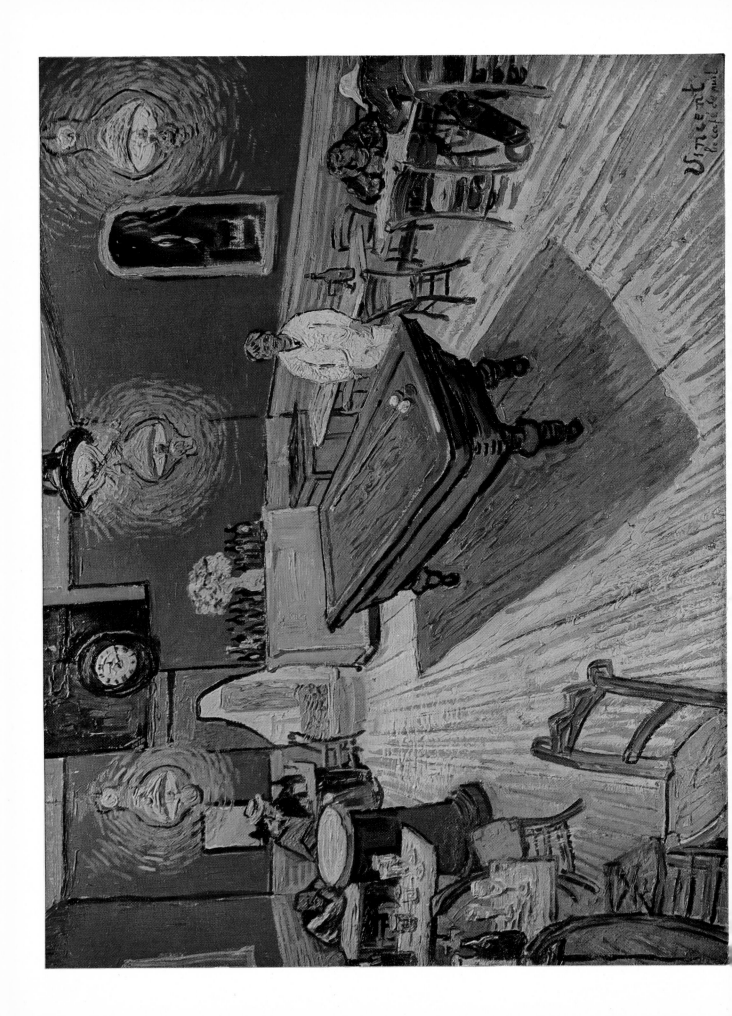

lovers by a marriage between two complementary colours, their mixture, their oppositions, the mysterious vibrations of close tints. Express the thought of a forehead by the spreading out of a light tone on a dark background. « He will disclose: « I tried to express with red and green the terrible human passions ». But before discovering painting which « like sorcerers and magnetizers, projects its thoughts at a distance » — as Baudelaire said when speaking of Delacroix paintings — he already tries to clear out the deeper meaning of things through the choice of objects and subject.

In his first paintings which he will multiply, especially from 1882 on, and which will be his Dutch period, he is faithful to the life of the poor. But he is no longer satisfied, as in his earlier drawings, to trace some striking but anecdotical episodes as, for instance, this long black line of miners going to work through the snow. He is obsessed by the symbolical strength of these endlessly repeated themes: « The man from the bottom of the abyss, *De Profundis*, is the coal-miner, the other one with a dreamy, almost thoughtful, almost sleep-walking expression is the weaver ». The first one « tears out from the bowels of the earth this mineral substance whose great necessity we all know ». The weaver, surrounded by a web of poles and threads, materializes these « prisoners in I know not what horrible cage » which we saw him mention before.

The simplest, most miserable, most scorned object takes on a violent bearing. Quite often Van Gogh will paint some shoes, old worn out shoes. Broken down, out of shape, gaping and deeply furrowed by wear they express the misery of walking bodies and of toil; they are weariness itself. In the same way he does not paint — not yet — flowers, but potatoes, loamy, buried in the soil from which they will have to be torn away, just as coal, to palliate men's destitution. He finds himself akin to those shapeless tubers in their hard fight to bloom!

As far back as in 1878 he felt rising in him the expressive strength of beings and things fighting in the dark to shoot up towards brightness. « You know, he wrote to his brother, that one of the roots of not only the Gospel's but of the whole Bible's fundamental truth is: 'from darkness to light' « *Per tenebras ad lucem!* This is already the meaning of all of his life, of his long trip to the end of the night; it is the re-discovery of the truth stated by the great mystics: only by deserving it in going through darkness can one reach the great lights... He knows this already: « Experience proves that those working in the dark, in the middle of the earth, as the miners in the black pits, are easily moved by the word of the Gospel and believe it with no effort ».

His first great painting, in 1885, sums up all this: *The Potato Eaters* are peasants, brothers of the miners: worn out at the end of a day of toil, greedy and uncouth, sitting around the table, they hanker after the steaming dish of humble food.

◁ THE NIGHT CAFÉ. Canvas, 28" × 35½" Arles Period, 1888.
Collection Stephen C. Clark, New York.

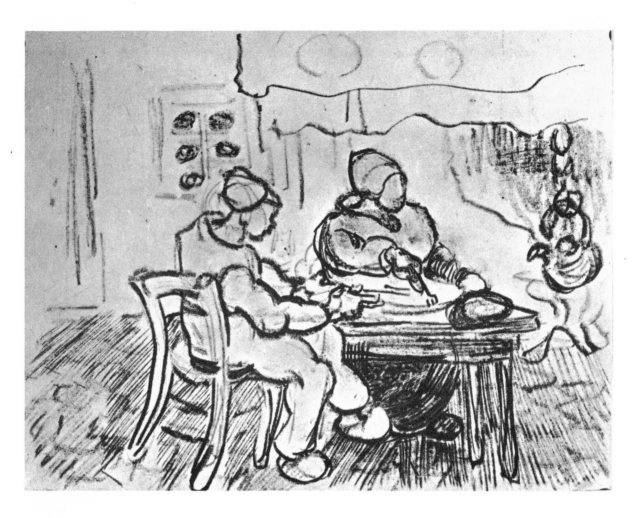

*Peasants at the Table. Lead pencil. 10" × 13" Saint-Rémy Period, 1889-90.*
*V. W. Van Gogh's Collection, Amsterdam.*

\* \* \*

From then on, Van Gogh too is leading towards light, towards colour, towards the sun. In 1885 his father died, and so did his past life. Vincent starts his progressive march towards the South. In November he lands in Antwerp, Flemish land, land of the Counter-Reformation, land of Rubens, land of exhuberant joy of living. Moreover, he discovers there the first Japanese etchings which are coming to Europe and are soon to disrupt the conception of taste. The time is close when he will abandon the « brown tones, for instance of bitumen and bistre » which alone could express the sad underground smouldering of his art.

In March 1886 he is in Paris and is hit by impressionism. He works in Cormont's studio where he meets Toulouse-Lautrec and soon makes friend with Gauguin, Pissarro and Seurat. The latest impressionist exhibition is just taking place at Durand-

Ruel's gallery. However, it is through Monticelli, — whose fat and powerful technique, clay impastement, chromatic and almost mineral resonance, he imitates — that he discovers both flowers and colour. But the impressionists lead him towards light which he can see emerging in its Parisian subtility. The shoot has broken through the earth's hard crust: it is now irresistibly drawn towards the sun.

Where can he find it? Through the Japanese engravings he gets glimpses of the Orient, the Empire of the Rising Sun. « So how could one not go to Japan, that is to its equivalent, the South? »

On the 21st of February, 1888 he is in Arles; he finds snow there, but a light and luminous snow which prepares him for the precocious spring of the Provence, its flowers, the white dust of its orchards, « something gay and tender ». For the first time, perhaps, Van Gogh is happy; he paints the white, innumerable petals, the apple

*Walking. Lead pencil. 10" × 13" Saint-Rémy Period 1888-90.*
*V. W. Van Gogh's Collection, Amsterdam.*

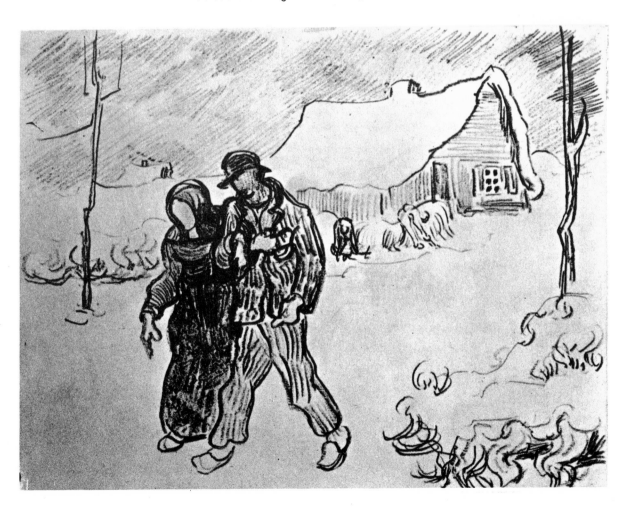

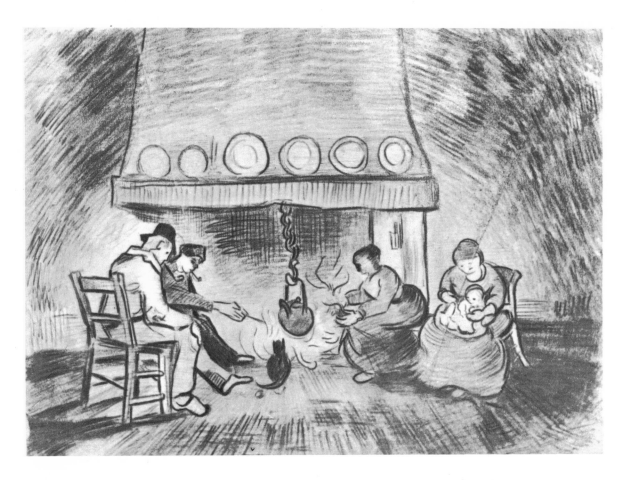

trees puffed up with a white and pink brightness; he paints this swarming of sparkling coolness.

The die is cast.  He will be a prey for the sun he sought for, unprotected against it, almost up-rooted; more so than Greco, and like him frantic, on the brink of insanity's, dizziness.  He is seeing his passionate, glaring dream come true, this dream toward which he was groping through his primary darkness, but on a land to which he was not native, and where it was not natural for him to live.  Like Greco, he will be torn between his hereditary and physical being, and the imaginary being he carries within, and to which life was offering an unexpected chance of materializing itself.  Neither his system nor his sensibility are built for this alcohol — despite the fact he craves for it — so he gets drunk until madness, until he dies of it.  Cezanne's story is exactly the opposite; when he arrived in this same Provence — from where he originated — all he had to do was to scratch the soil a little in order to get closer

to his own roots and to discover himself; under the scorching intensity of this sun he will achieve harmony, whereas Van Gogh will burn himself out.

Van Gogh now becomes the prey of the sun and during the three years left to him, he will in a curious way follow its seasonal rhythm. He bursts out with spring, reaches his highest point during summer and discovers July and the flame's plenitude. The sign of the fire will show in his colour brought by a breathless and melting touch of red and blue to yellow, « a sun, a light, that for lack of a better name I can only call yellow, pale sulphur yellow, pale lemon. How beautiful is yellow ! « With a kind of obsession he multiplies, to decorate his studio, large paintings of turnsoles, which are often called « sunflowers » because they call the sun to the mind by their shape, their colour, their heliotropism: in them he recognises himself. And in his landscapes he often draws, behind haystacks — another deeply significant symbol — the fiery globe in the sky, as Claude Le Lorrain used to do.

At this time of plenitude and happiness, it seems he has exorcised the malediction of the individual, of the man alone. Impressionism had already suggested to him the idea of a group painting, where the gifts of each and every one would plunge back into community. He wants paintings « to go beyond the power of one individual ». This is when he dreams of founding in Arles this « Studio of the South » where, with Gauguin who will answer his call, Lavalle and Bernard, were also supposed to join him.

*Carriage Drawn by a Horse. Lead pencil. 8½" × 10" Saint-Rémy Period, 1889-90.*
*V. W. Van Gogh's Collection, Amsterdam.*

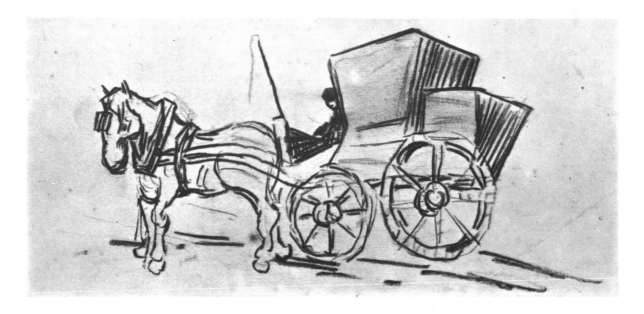

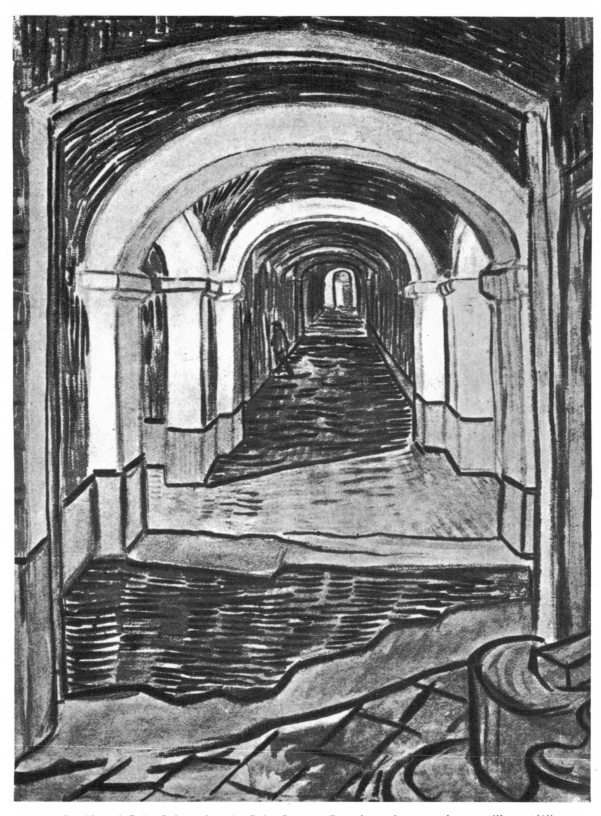

*Corridor of Saint-Pol Asylum in Saint-Remy.  Gouache and water-colour.  26″ × 19½″*
*Saint-Rémy Period, 1889.  V. W. Van Gogh's Collection, Amsterdam.*

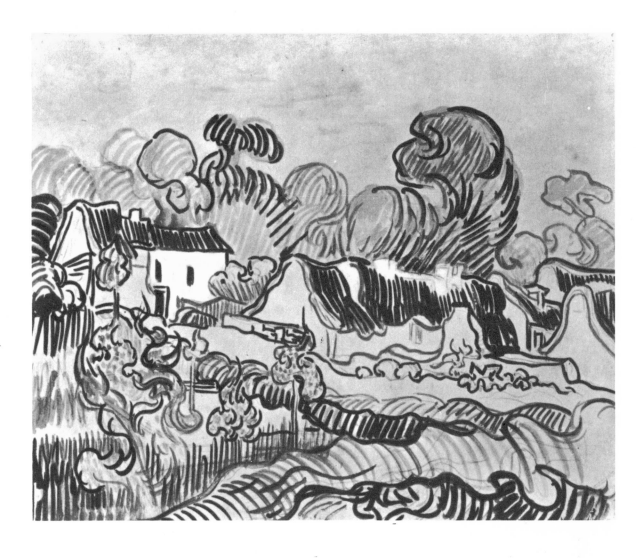

*Wooded Landscape.   Drawing, blue distemper and charcoal. 18" × 22"   Auvers Period, 1890.*
*V. W. Van Gogh's Collections, Amsterdam.*

He also goes beyond himself because he discovers universal life.   « I am painting infinity ».   From the rock of Montmajour, he no longer sees a foggy northern plain, with lost visibility, preliminary shape of something unlimited, but a large shadowless space, entirely visible in its smallest details.   This represents at the same time the infinitely vast: the plain stretching beyond what the eye can see, and the infinitely small: the multiplication of fields, olive groves, vineyards, stones, where life swarms with a dust of visible marks, myriads of microscopic pores of the earth's face.

It is now the zenith of July: « I feel inside me a strength which I must expand, a fire which I can not put out, but which I must nurture, although I don't know to which exit it will lead, and I would not be astonished if it were a dark one ».

He feels he is dedicated to the fire, but he knows at the same time that the end of any fire is ashes.   His colour, which one might believe freed from their origi-

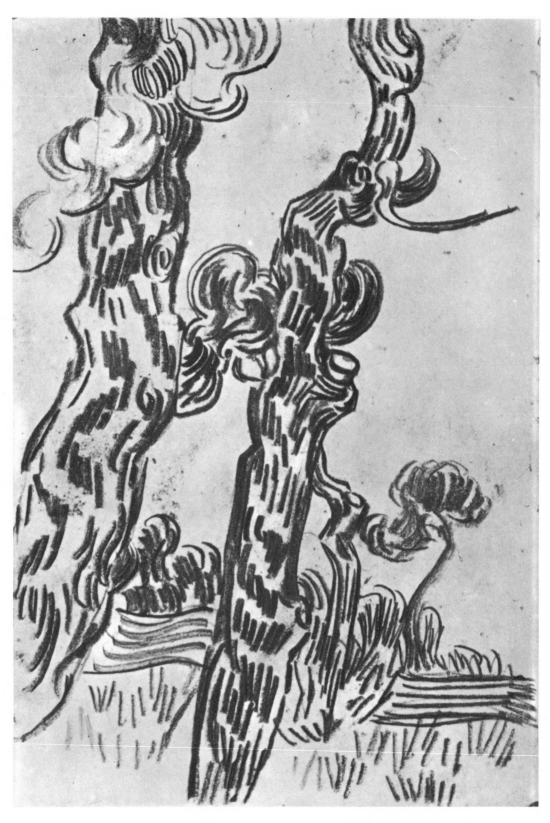

*Two Pine Trees. Lead Pencil. 12" × 8½" Saint-Rémy Period, 1889-90.*
*V. W. Van Gogh's Collection, Amsterdam.*

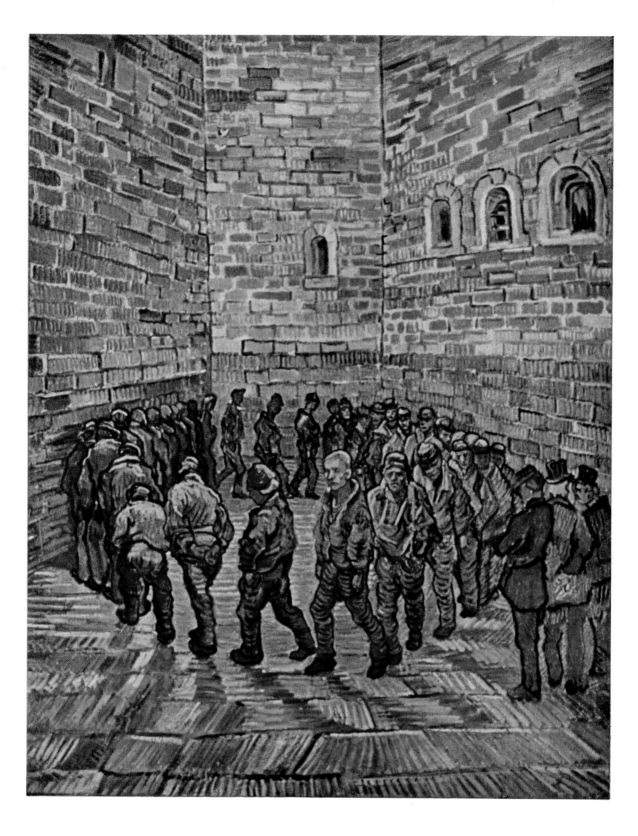

THE PRISON COURT-YARD (After an engraving by Gustave Doré). Canvas, 32" × 25$\frac{1}{2}$"
Saint-Rémy Period, 1890. Museum of Modern Art, Moscow

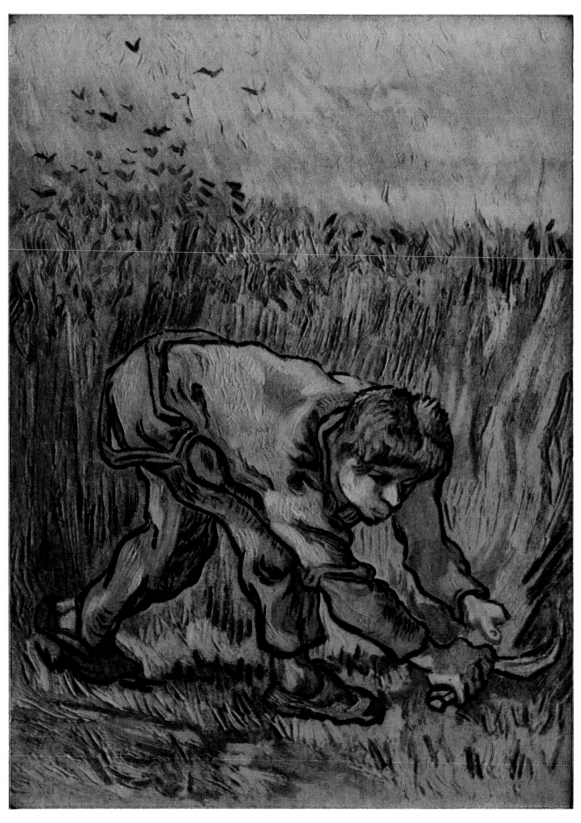

THE REAPER (After Millet).  Canvas, 17½" × 13½"  Saint-Rémy Period, 1889
Collection V. W. Van Gogh, Amsterdam

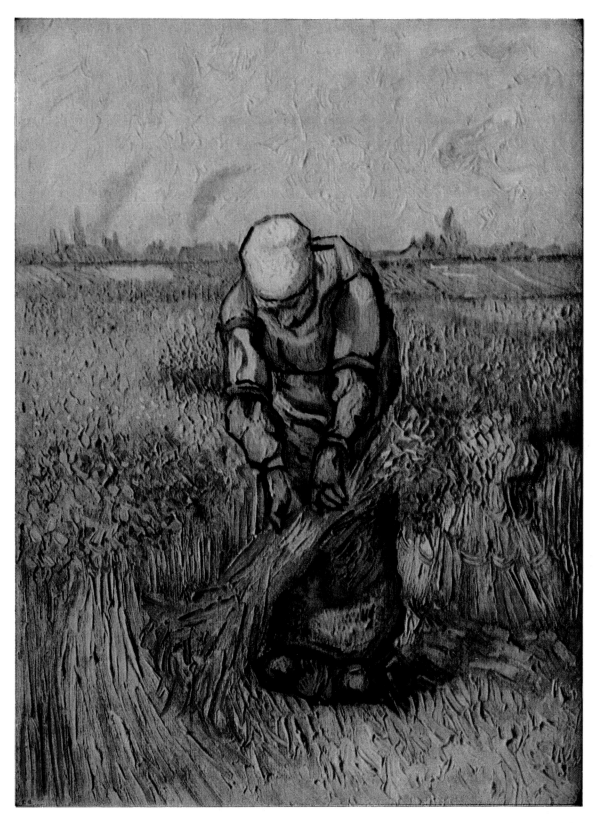

PEASANT-WOMAN BINDING THE CORN IN SHEAVES (After Millet). Canvas, 17½" × 13½"
Saint-Rémy Period, 1889. Stedelijk Museum, Amsterdam

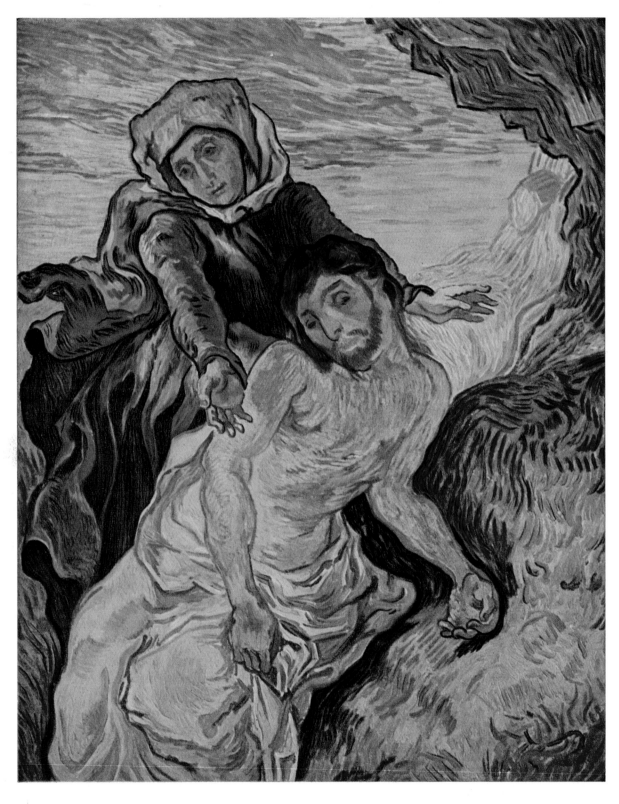

PIETÀ (After Delacroix). Canvas, 29¹/₄″ × 24¹/₄″ Saint-Rémy Period, 1889
Collection V. W. Van Gogh, Amsterdam

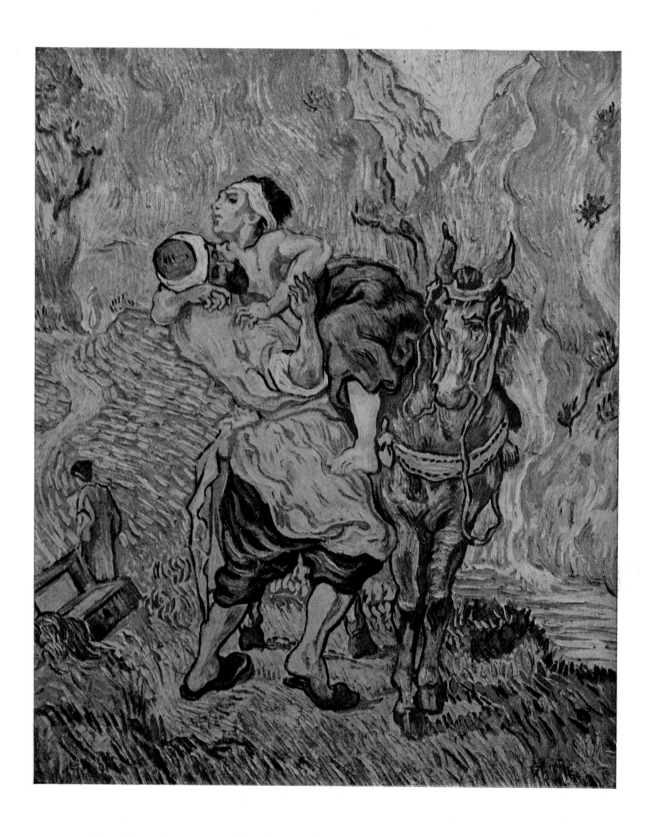

THE GOOD SAMARITAN (After Delacroix).  Canvas, 29¼" × 24"  Saint-Rémy Period, 1890
Kröller-Müller Museum, Hoenderlo

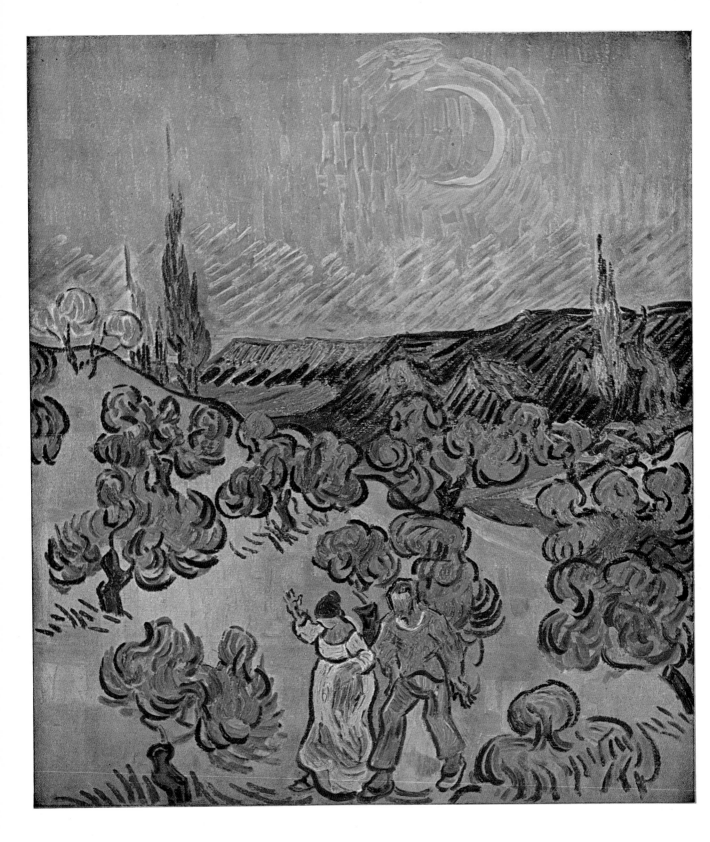

THE EVENING WALK.  Canvas, 20" × 26¼"  Saint-Rémy Period, 1889.
Sao Paulo Museum

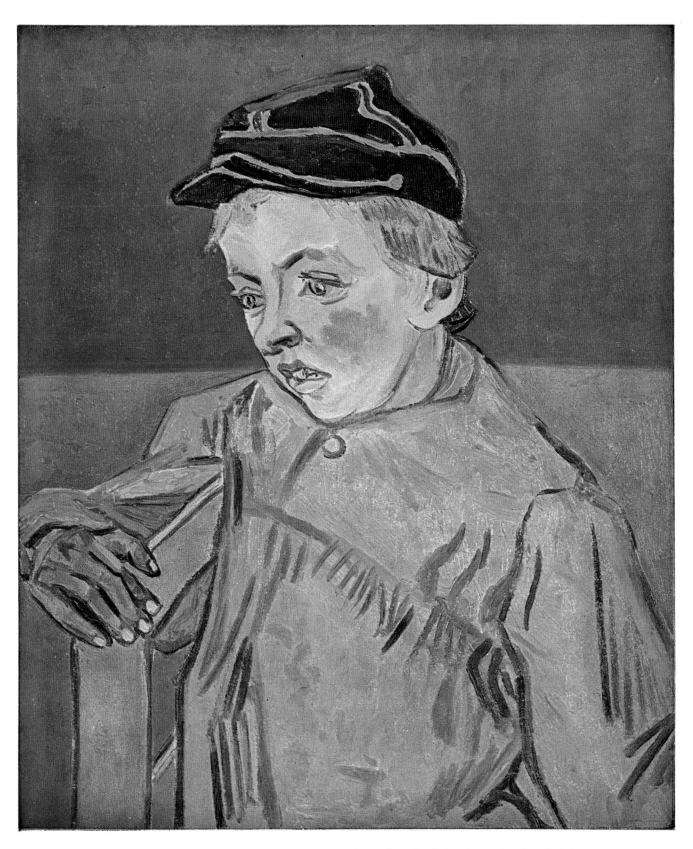

THE SCHOOLBOY.   Canvas, 25¼" × 21½"   Saint-Rémy Period, 1890.   Sao Paulo Museum

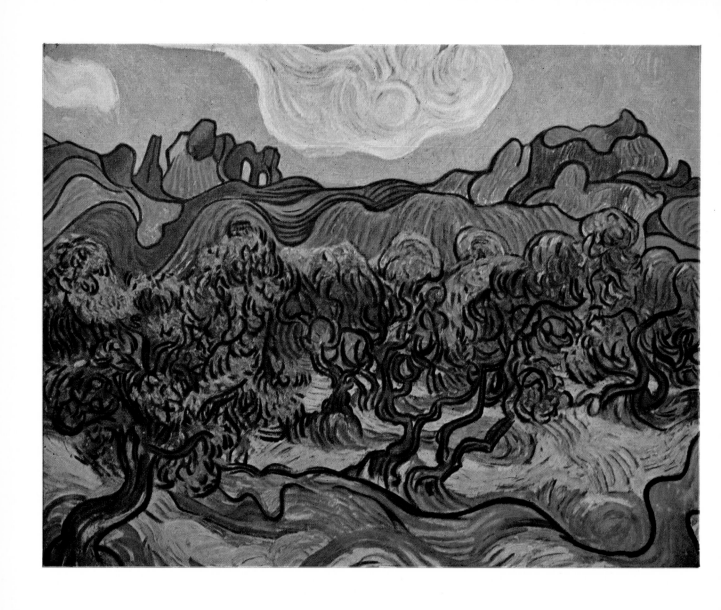

THE OLIVE TREES. Canvas, 29" × 36½" Saint-Rémy Period, 1889
Collection J. Hay Whitney, New York

*The Cabriolet. Black Pencil, 13½" × 11", Saint-Rémy Period*
*V. W. Van Gogh's Collection, Amsterdam*

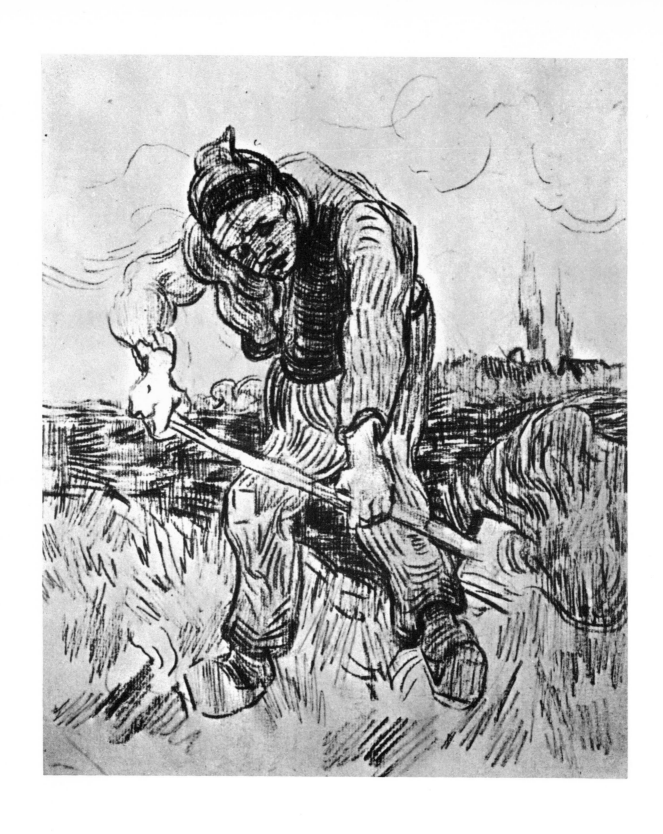

*Peasant Hoeing. Black Pencil, 13½″ × 11″, Saint-Rémy Period*
*V. W. Van Gogh's Collection, Amsterdam.*

*Interior. Lead Pencil, 11" × 12", Saint-Rémy Period
Mrs J. Van Gogh Bonger Collection, Amsterdam.*

nal shadows, develops. The cypress, this dark and funeral tree, starts appearing. Soon the pure yellows, the yellows of Vermeer which he used at the beginning, glide towards the reddish-brown of haystacks. Then they change into copper, and from copper into bronze.

<p style="text-align:center">* * *</p>

The tragedy starts. The new Icarus can soar towards the sun, but he will weaken and fall. He can cry, as in Baudelaire's verses:

> Under I do not know what fiery eye
> I feel my wing breaking.

In October Gauguin arrives. Enthusiasm is soon replaced by quarrels. Van Gogh finds out that the ego remains incompatible, and even incommunicable. Moneyless, he does not eat every day. Only spirits can sustain him, and excited by absinth taken on an empty stomach, he stays for hours working under a glaring sun, not made for his northern head.

Here comes the winter solestice! Three days later, on the 24th of December, Van Gogh throws his glass into Gauguin's face. The next day, as Gauguin is walking in the street, he hears rapid footsteps behind him, turns around and beholds Van Gogh, holding a razor and marching on him. Gauguin stares him to a halt; then, Van Gogh runs away.

He runs home and, back in his room, he cuts off his ear with the razor, wraps it up in a handkerchief, and goes out to offer it to a brothel's wench. The motivation of this act has been discussed at length. Transposed on Vincent's then extraordinary nervous over-excitment, it appears perfectly coherent with everything we know about him. He failed once more in his dream of a collective studio, and in his dream of friendship. Failure and guilt... His action calls to the mind, Lafcadio's self-punishment penknife stabs, imagined by Gide, another Protestant... Punishment is linked with the idea of self-gift and of the gift of sacrifice to the humble: this is why he will go and take to the lowest woman, to this sister of Christine, this piece of flesh, which he cut from himself as a punishment.

1889 starts with the internment first in Arles, then in the St. Rémy asylum, on the 9th of May. Spring has started the solar cycle again. Now that the balance is broken, the frenzy which already rose in Arles is amplified: « The row of bushes at the end are all rose-laurel, raving mad; the damp plants are blossoming in such a way, that they should indeed catch a locomotor ataxy... Their greenery too, renews itself by vigorous new shoots, which seem inexhaustible... ».

The solar blaze changes him into a real burning bush. His mind gives itself away to a dizziness which is beginning to intoxicate him. Panorama's infinity takes on a hallucinatory nature. Life which he sensed everywhere, starts shaking, starts

*Peasant Woman in a Corn Field. Black pencil. 12" × 9" Auvers Period, 1890.*
*V. W. Van Gogh's Collection, Amsterdam.*

*Study of a Fruit Tree with Two Working Figures.*
*Black pencil. 12½" × 9½" Auvers Period, 1890.*
*V. W. Van Gogh's Collection, Amsterdam.*

moving: it upsets shapes, it ripples, it swells like an ocean under the ground's shell. It intensifies everything: the enormous multiplication of grass, of leaves, space rushing, dashing towards the horizon like a fire-ball, the movements of the earth which crawls, wells, rocks, the movements of the leaves overlapping each other, breaking loose with the suction of air.

In a sort of general vibration, everything rocks, and tumbles, everything spreads in a breath-taking dizziness which is the breath of the universe itself freed of all constraint.

But ashes are already dimming the fire. Everywhere now, cypresses, which still leap up like sparks towards the sky, bring with them the colour of the night. Before the end of the summer, violets and pale blue are here, there and everywhere about the olive trees. Behind the dying flowers the crackling of the dying fire can be heard. He shudders: « Careful of the feast's tomorrows, careful of the winter Mistral!... the results of this terrible attack are that my mind hardly harbours any more clear desire or hope. I wonder whether this is how one feels when, with passions dimmed out, one comes down from the mountain instead of climbing up? »

82

He comes back to a subject he had painted in 1882: « getting ready for the great journey »: a desperate old man, holding his head. Sun is out of the question. The old man is sitting near a poor fireplace where a smoky spit is still burning, but about to go out.

* * *

Then stalked by illness, haunted by the desperation to win, he flees towards the north, towards his native sky: So strong is the pining for his youth that he even speaks of coming back to the grey colouring of his debut. He runs to hide the mortal wound made to him by the sun. Near Paris, by Pontoise, in Auvers, he puts himself into Dr. Gachet's hands. The doctor was recommended by his brother. :

*Study Sheets. Black pencil and lilac coloured ink. 9" × 12" Auvers Period, 1890.*
*V. W. Van Gogh's Collection, Amsterdam.*

*A Hut in Blue Pencil.  9½" × 12½"  Auvers Period, 1890.*
*V. W. Van Gogh's Collection, Amsterdam.*

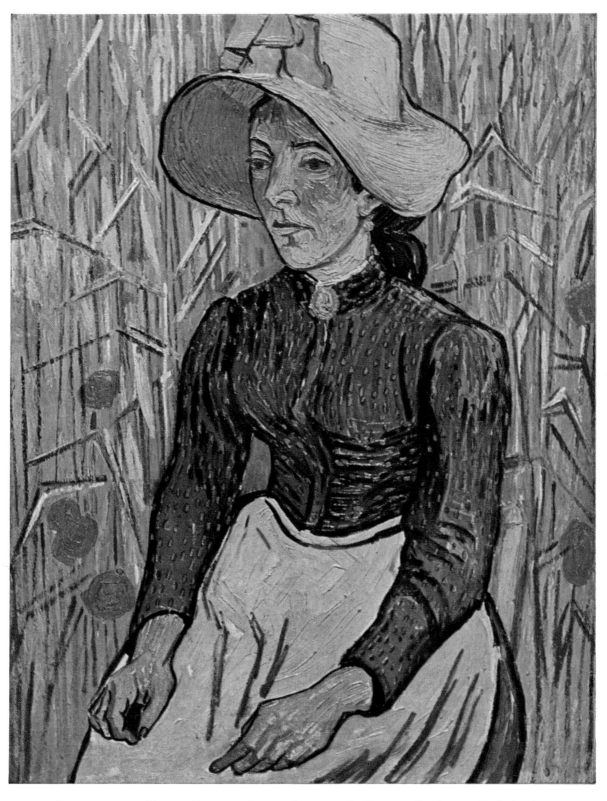

PORTRAIT OF A YOUNG PEASANT GIRL. Canvas, 36½" × 29¼" Auvers Period, 1890
Collection Hahnloser, Winterthur

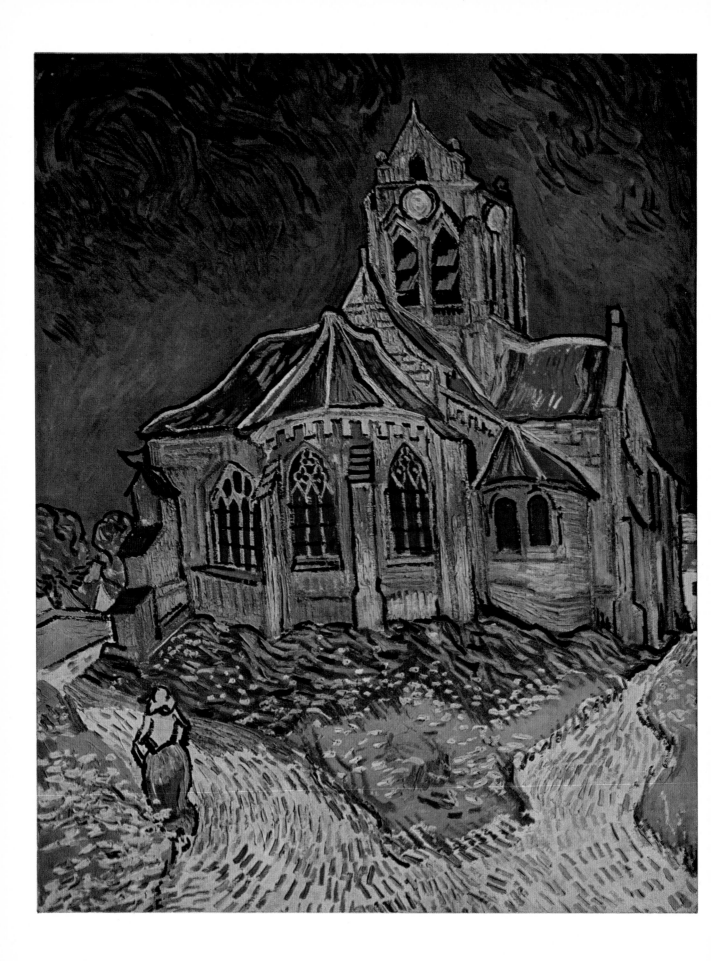

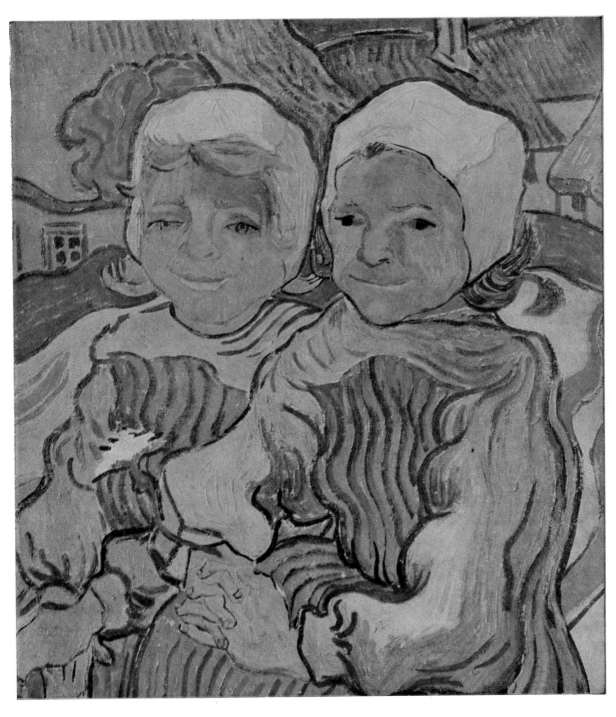

Two Children. Canvas, 20½" × 18¼"  Auvers Period, 1890
Collection Mme H. Glatt Kisling, Zurich

◁

The Church at Auvers.  Canvas, 37¼" × 30"  Auvers Period, 1890
Louvre Museum, Paris (Collection Gachet)

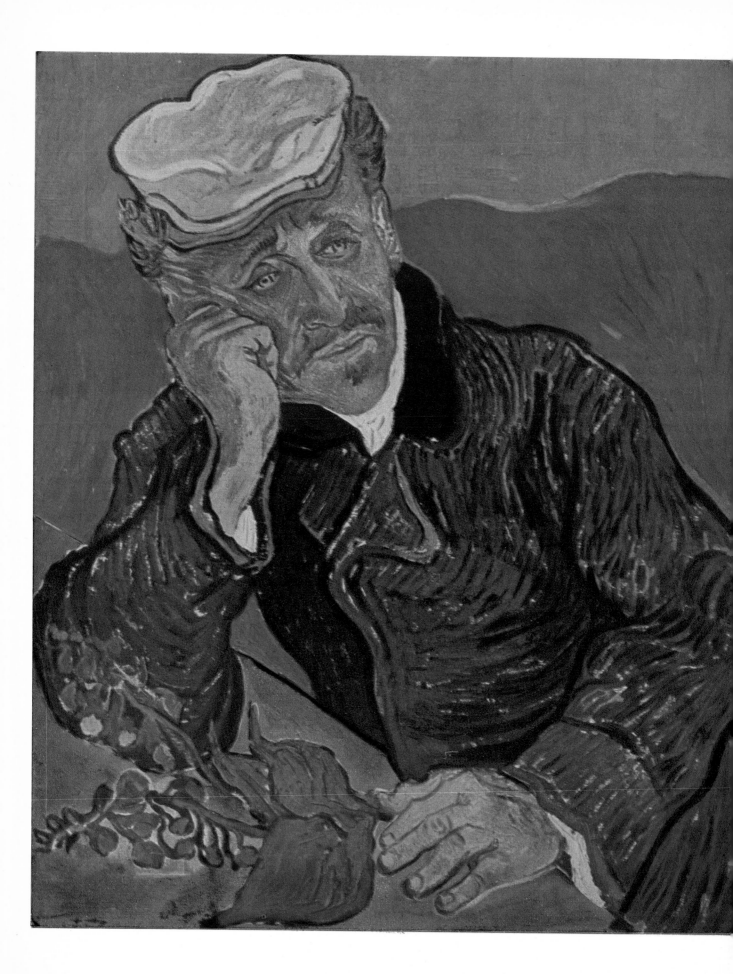

*Mademoiselle Gachet at the Piano.  Black pencil.  12½″ × 9½″  Auvers Period, 1890.*
*V. W. Van Gogh's Collection, Amsterdam.*

◁

PORTRAIT OF DR. GACHET.  Canvas, 27″ × 22½″  Auvers Period, 1890.
Louvre Museum, Paris (Collection Dr. P. Gachet).

We are again in May, 1890 this time. The frantic violence of his paintbrush spurts and spreads out as never before, but like waves breaking on a rock. Look at it closely: the dazzling arabesques of older days are replaced by a restive graphism, by small, stiff, broken, almost forced sticks. The touch, as the design, is somewhat broken and breathless. One can feel, that physically, muscularly, nervously, the hand no longer answers. The painting may thus acquire something more powerful, more tragic, more moving, Van Gogh can guess it is the end; he is on his way down from the mountain. « Here, having come back, I started working again, the brush almost falling out of my hands — and knowing exactly what I wanted, I still painted three large canvases ». He still wants, he still conceives, with perhaps more genius than ever, but the hand slips away. And what are those canvases? « Large cornfields under troubled skies. I had no scruples trying to express sadness, extreme loneliness ».

*Cornfield with Ravens!* In Paris, when he was rising towards the sun, would throw a merry skylark on golden corn. Now the corn is almost brown, made of touches which, in their utmost vehemence, seem to coagulate and to break themselves: now he can only see the ravens. And because this time the crescendo of summer did not lead him anywhere, on the 27th of July 1890, he shoots himself in the chest. With his silent courage, he comes back, leaving behind a bloody trail in the dust, goes up to his room, in the café where he lived, lays down like a wounded animal, and like a wolf in his den, he calmly starts dying. Dr. Gachet rushes to his side, stays up with him, hopes to save him, but two days later, complications set in and Vincent dies. He had scribbled these last words for his brother Theo: « for my own work I am risking my life, and my mind is half gone... But what do you want? »

But what do you want?

The question is open on a white sheet of paper where no answer was ever to be written, except the answer of fame.

* * *

Thus was the life of Van Gogh. Absolute failure for him, sublime success for us, but he never knew it: « Under some circumstances it is better to be the loser than the winner, it is better to be Prometheus than Jupiter ».

Vanquished, maybe! but through a defeat which is the most beautiful of victories. Yes, complete failure: in individual love, in collective love, in pictural endeavour (Could he think otherwise? He, who almost never sold any of his pictures, who saw those he offered either refused or neglected!), physical and moral failure of a system and a mind both ruined at the age where others reach their plenitude.

Isn't it the picture of a completely wasted life? He must have felt it such to go to the end of what was his destiny: that is a total gift of himself, the redemption of his ego, exalted by the total sacrifice of everything which he had a right to expect. Van Gogh will have lived this admirable and perhaps unique passion; he will have greedily educated and developed his ego and will not have gotten anything out of it for himself but disappointment and finally the excruciating feeling of having achieved nothing in this life — a useless life.

But it is because of this that he is so great, because of this that his genius appears to us with the purity of a saint of painting. For, when he assumed his own nothingness, he started becoming for others, for ever increasing multitudes, a warming and illuminating fire. This lost fire, hardly noticeable by a barren smoke, has now changed into a sun, a sun whirling in our eyes and in our hearts and projecting its splendor — splendor made of flame, of love, of life.

FIELD UNDER A STORMY SKY. Canvas, 20'' × 40''  Auvers Period, 1890.
V. W. Van Gogh's Collection, Amsterdam.

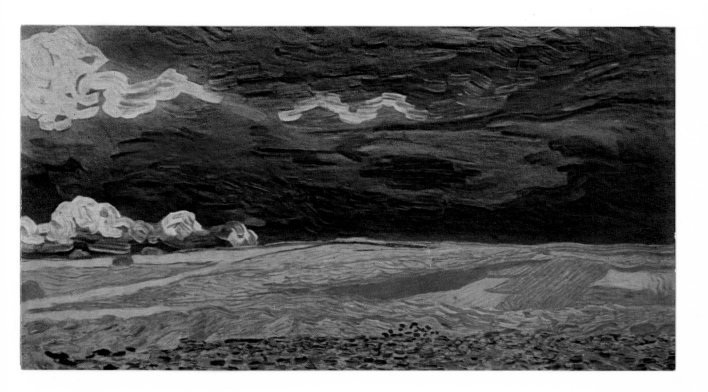

# BIBLIOGRAPHY

## GENERAL INDICATIONS

MATTOON BROOKS, Charles: *Vinc. V. G.* A Bibliography comprising a catalogue of the literature published from 1890 to 1940. (777 nos) New York, 1942.

PERRUCHOT, Henry: *La Vie de V. G.*

## LETTERS

*La correspondance complète* 4 vol. *Verzamelde Brieven van Vinc. V. G.* a paru à Amsterdam, Wereld-Bibliothek, 1952-1955.
His letters to his brother *Théo* (652) published by Johanna van Gogh-Bonger 3 vol.: *Brieven aan zijn broeder*, Amsterdam, 1914-1925.
His letters to his Mother, Paris, Ed. Falaize, 1952. (Aiso Mercure de France, 1952).
Letters to *V. Rappard* (58), Amsterdam, 1937, Paris, Grasset, 1950.
Letters to *Emile Bernard* (21) Vollard, Paris, 1911.

Letters to à *John Russell* (3) « l'Amour de l'Art », Sept. 1938.
Also: *Briefe an E. Bernard, P. Gauguin, P. Signac und andere*, Bâle, 1938; Mercure de France, 1893, 1895, 1897, oct. 1903; Beaux-Arts, 10 mars 1939 (à Gauguin); *Lettres de Gauguin*, publiées par Malingue, Paris, Grasset, 1946; Figaro littéraire, 22 mai 1954 (à sa soeur) et Gachet, Paul: *Lettres impressionnistes au Dr. Gachet et à Murer*, Paris, Grasset, 1957.

## CATALOGUES

LA FAILLE, J. B. de. *L'Oeuvre de Vincent van Gogh.* Catalogue raisonné. 4 vol. Paris et Bruxelles, Van Oest, 1928. - New édition for the painting only, with introduction by Charles Terrasse. Paris, Hyperion, 1939.
SCHERJON, W.: *Catalogue des tableaux par Vinc. V. G. décrits dans ses lettres.* (St. Rémy et Auvers). Utrecht, 1932.
SCHERJON, W. and GRUYTER, W. de. *Vinc. V. G's Great Period*, Amsterdam, De Spieghel, 1937.
VANBESELAERE, W.: *Catalogue de la Période Hollandaise.* Anvers, de Sikkel, 1938.
*Catalogus Vinc. V. G.* (Introduction by W. Steenhoff) s. d. Amsterdam, Stedelijk Museum.
*Catalogus Tentoonstelling Vinc. V. G. en zijn tijd genooten*, sept-nov. 1930. Ed. J. B. de La Faille. Amsterdam, Stedelijk Museum.
264 *Werken van Vinc. V. G.*, Rijksmuseum Kröller-Müller, Otterlo, 1949.
BARR, Alfred H. Jr. *Vinc. V. G.* The Museum of Modern Art, New York, 1935-1936.

*Exposition van Gogh.* juin-oct. 1947. Exposition Internationale, Paris, 1937. (Groupe 1, Classe 3), organisée par R. Huyghe.
Catalogue par M. Florisoone. Ed. Amour de l'Art.
*Vinc V. G.*, Bruxelles, Palais des Beaux-Arts, nov.-déc. 1946. Catalogue par E. Langui. Ed. de la Connaissance.
Also to be mentioned, the catalogues of the exhibition 1947 par The Arts Council of Great Britain, Musée de l'Orangerie, Paris, (janv.-mars. Foreword by de V. W. Van Gogh et R. Huyghe); - in 1951, Lyon (préfaces de V. W. van Gogh et R. Jullian), in Houston, Texas The Contemporary Arts Museum (Fev. Foreword by de Th. Rousseau); - 1953, à Amsterdam, au Stedelijk Museum Otterlo, au Rijksmuseum, Kröller-Müller; - 1954, in Paris, Musée de l'Orangerie (V. G. et les peintres d'Auvers, nov-fév. 55, Foreword by Paul Gachet et G. Bazin); Zürich, Kunsthaus (oct.-nov.) 1953 (janv.-mars). Exhibition of drawings and watercolors.

# GENERAL WORKS

ARTAUD, Antonin: *V. G. le suicidé de la société.* Paris, 1947.

AURIER, G. A.: *Oeuvres posthumes.* Paris, Mercure de France, 1893.

BEUCKEN, J. de.: *Un portrait de Vinc. V. G.* Liège, Ed. du Balancier, circa 1938.

BREMMER, H. P.: *Vinc. V. G. inleidende beschou-wingen.* Amsterdam, W. Versluys, 1911.

CASSOU, J. et REWALD, J.: *Vinc. V. G.* Paris, La Renaissance, 1937.

COGNIAT, Raymod, *V. G.* Paris, 1953.

COLIN, P.: *V. G. « Maîtres de l'art moderne ».* Paris, Rieder, 1925.

COQUIOT, G.: *Vinc. V. G.,* Paris, Ollendorf, circa 1923.

DU QUESNE-VAN GOGH, E. H.: *Persoonlijke Herin-neringen aan Vinc. V. G.* Baarn. J. F. van der Ven, 1910. Traductions: allemande, Munich, Piper, 1913; anglaise, Londres, Constable, 1913.

DURET, Théodore: *Vinc. V. G.* Paris, Bernheim Jeune, 1924.

ESTIENNE, Charles: *V. G.* Biographie par C. H. Sibert (Coll. Goût de notre temps, ill. couleurs). Genève, Skira, 1953.

FELS, F.: *Vinc. V. G.* Paris, Stock, 1924.

FLORISOONE, Michel: *V. G.* Paris, Plon, Ed. d'Histoire et d'Art, 1937.

GLASER, Curt: *Vinc. V. G.* Leipzig, E. A. Seemann, 1921.

GOLDSCHEIDER, L. et UHDE, W.: *Vinc. V. G.* Paris, Phaidon, 1936.

GREY, Roch, *V. G.* Rome, Valori Plastici, et Paris, G. Crès, 1924.

HAMMACHER, Arno. *V. G. The land where he was born and raised, a photographic study.* La Haye, L. J. C. Boucher, 1953.

HARTLAUB, Gustav: *Vinc. V. G.* Leipzig, Klinh-kardt und Bierman, 1922.

KNUTTEL, G.: *V. G. der Hollander,* Stockholm, 1933.

KRAUS, G.: *The relationship between Theo and Vinc. V. G.* Amsterdam, Meulenhoff, 1954.

LA FAILLE, J. B. de.: *L'Epoque française de V. G.* Paris, Bernheim Jeune, 1927.

LAPRADE, Jacques de.: *V. G.* (Coll. Ars Mundi), Paris, Somogy, 1951.

MEIER-GRAEFE, J.: *Vinc. V. G.* Munich, R. Piper & Co., 1910, 1918, 1921, 1922, 1925. *Vincent* 2 vol. Münich, R. Piper & Co., 1925. *Vincent V. G. der Zeichner.* Berlin, Otto Wecker Verlag, 1928.

PACH, Walter: *V. G.,* New York, Artbook Museum, 1936.

PERRUCHOT, Henri: *La vie de V. G.* Paris, Hachette, 1955.

PFISTER, Kurt: *Vinc. V. G. sein Werk,* Potsdam, G. Kiepenheuer Verlag, circa 1922.

PIERARD, Louis: *La vie tragique de Vinc. V. G.*

ROELANDT, L.: *Vinc. V. G. et son frère Théo.* Paris, E. Flammarion, 1957.

ROSE et Dr. M. J. MANNHEIM: *Vinc. V. G. im Spiegel seiner Handschrift,* Bâle-Leipzig, S. Karger, 1938.

STERNHEIM, Carl: *Gauguin und van Gogh.* Berlin Die Schmeide, 1924.

STONE, Irving: *La vie passionnée de V. G.* (Adaptation francaise de Paul-Jean Hugues). Paris, Flammarion, 1938.

TERRASSE, CH.: *V. G.* Paris, Laurens, 1932; *V. G.* Paris, Floury, 1935.

TIETZE, Hans: *Vinc. V. G.* (Kunst in Holland, n. 14). Wien, B. Filser & Co., 1922.

# ALBUMS

Albums on the collection Hidde Nyland (Amsterdam, 1905) et H. Kröller-Müller (La Haye, 1919); R. Piper et Co., Munich, 1912 et 1924; Marces Gesellschaft, 1919 et 1928; A. Juncker Verlag; W. Versluys, Amsterdam; E. A. Seeman, Leipzig; P. Fierens, (Coll. Peletter), Paris, Braun, 1947.

Albums in color: Frank Elgar, Paris, Ed. du Chêne, 1947; Meyer Schapiro, New York, Abrams, 1950; J. Leymarie, (Coll. Le grand art en livres de poche), Paris, Flammarion, 1953. J. B. de La Faille (album avec 50 pl.),

Amsterdam; F. Fels, Paris, Stock, 1934; Pié-rard, Paris, Braun, 1936; Lamberto Vitali, Milan, Hoepli, 1936; Album d'Art Druet, pré-face par Waldemar George, Paris, Librairie de France, s. d.

On the drawings: *V. G. der Zeichner,* Berlin, Otto Wacker, s. d.; R. Huyghe, *Van Gogh.* (Galerie d'estampes), Paris, Braun, 1938; *V. G. et les peintre d'Auvres chey le Docleur Gachet,* pré-face d'A. Malraux (and by R. Huyghe in the German edition), Paris, L'Amour de l'art, 1952.

# MEDICAL AND PSYCHOLOGICAL STUDIES

BATAILLE, Georges: *La Mutilation sacrificielle et l'oreille coupée de V. G.*, Documents n. 8, Paris, S. d.

BEER, DR. F. J.: *Les rapports de l'Art et de la maladie de V. G.*, thèse, Strasbourg, 1935.

CATESSON, DR. J.: *Considérations sur la folie de V. G.*, thèse, Paris, 1943.

DOITEAU, V. et LEROY E.: *La folie de V. G.*, Paris, Esculape, 1928. *V. G. et le drame de l'oreille coupée*. Ibid. 1936.

EVERSEN, DR. Hans: *Die Geisteskrankheit Allgemeine Zeitschrift für Psychiatrie*, Fév. 15, 1926.

JASPERS, Karl: *Strindberg und V. G.* (Arbeiten für augeswandte Psychiatrie, n. 5). Leipzig, Bircher, 1922.

JOHNSON, Helen Apel: *No Madman*, Art Digest, Fév. 1934.

RIESE, Walther, *Ueber den Stilwandel bei Vinc. V. G.*, Zeitschrift für die Gesamte Neurologie und Psychiatrie, 2 mai 1925.

*Vinc. V. G. in der Krankheit.* (Dans la série « Grenzfragen des Nerven und Seelenlebens »). München, J. F. Bergmann, 1926.

SHIKIBA, DR. R.: *La vie de V. G. et sa maladie mentale*. Tokio, 1932.

# STUDIES ON THE FALSE VAN GOGH'S

FAURE, Elie: *A propos des Faux van Gogh*, « L'Art Vivant », Paris, 1er avril, 1930.

LA FAILLE, J. B. de.: *Les Faux van Gogh*, Formes, Paris, déc. 1929. - *Les Faux van Gogh*. Paris et Bruxelles, van Oest, 1930. - *Réponse à*

*l'article de M. Elie Faure*, « L'Art Vivant », Paris, 15 juin 1930.

UEBERWASSER, Walter: *Le jardin de Daubigny; das letzte Hauptwerk van Goghs*. Basel, Verlag Cratander, 1936.

# MAGAZINE ARTICLES

Aurier, Albert: *Les Isolés : Vinc. V. G.*, « Mercure de France », janv. 1890.

Bernard, Emile: *Vinc. V. G.*, « Mercure de France », 1893.

Denis, Maurice, *De Gauguin et de V. G. au classicisme*, « L'Occident », Mai 1909.

Duthuit, Georges, *Le Drame des Alyscamps*, « L'Amour de l'Art », août 1927.

Gachet, Paul, dans *Le Dr. Gachet et Murer*, Paris, Ed. des Musées Nationaux, 1956.

Gauguin, Paul, dans *Avant et Après*, Paris, G. Grès, 1924.

Hertz, Henri, *La crise présente des arts plastiques (témoignage et argument de V. G.)*, « L'Amour de l'Art », juillet 1922.

Huyghe, René: *Querelles muséographiques - pour ou contre l'exposition V. G.*, « Micromegas », 10 oct. 1937. - *Le Rôle des musées dans la vie moderne*, « Revue des Deux Mondes », 15 oct. 1937. - dans *Le Carnet de Paul Gauguin*, (sur les rapports des deux peintres) 2 vol. Paris, Quatre Chemins, 1952.

Leroy, Dr. Edgard: *La Provence et V. G.*, « Revue des Pays d'Oc. », juin 1932.

Nordenfalk, Carl.: *V. G. and Littérature*, Jae Warburg and Courtauld Inst., vol. 10. 1947.

Piérard, L.: *V. G. au pays noir*, « Mercure de France », juillet 1913.

Rewald, John: *Précisions sur V. G.*, « L'Amour de l'Art », juillet 1936. - *V. G. en Provence*, « L'Amour de l'Art », oct. 1936 - *Post-Impressionism from V. G. to Gauguin*, New York, The Museum of Modern Art, 1956. (Bonne bibliographie; 264 nos).

Vlaminck, Maurice: *Le Ventre ouvert*, Paris, Corréa, 1937, pp. 180-181.

Vollard, Ambroise: *Souvenirs d'un marchand de tableaux*. Chap. VII. *Cézanne et V. G.*, Paris, Albin Michel, 1937.

Werth, Léon: *Quelques peintres*. Chap. V. G. Crès, 1923. Articles dans: De Amsterdammer; The Burlington Magazine; Der Cicerone; Elsevier's Geill. (Maanschrift); Glos Plastykov; Volne Smery etc. N° special de Mededelingen, La Haye, 1953.

# ILLUSTRATIONS